IMAGES
of America
COVINGTON

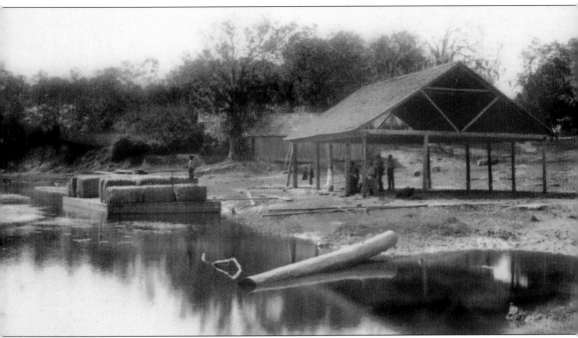

The history of Covington has long been tied to the waters flowing in the Bogue Falaya River. The landing at the end of Columbia Street has been the gateway for goods and commodities produced in St. Tammany Parish and the surrounding areas, and Covington has been at the hub. Supplies and raw materials flowing into the town also made their way along the river to be deposited on the shores of Covington. This photograph shows bales of cotton waiting to be shipped from the river to Lake Ponchartrain and to points beyond. When one thinks of the singular feature significant in the establishment of the town of Covington, it is always the river. (Courtesy of H.J. Smith Hardware.)

ON THE COVER: John Louis "Deed" Smith sits in a wheelbarrow holding two bouquets of flowers, almost certainly as the result of a lost bet. The sign notes J.L. Watkins as the proprietor of the City Drug Store, which was situated on Columbia Street where Roy's Knife Shop is today. Deed Smith was the grandson of John Edis Smith, who opened his first hardware store in St. Tammany around 1846. Some version of Smith Hardware and/or General Store has been a presence in Covington since the town's earliest days. The current establishment on Columbia Street continues to be run by his descendants. (Courtesy of H.J. Smith Hardware.)

IMAGES of America
COVINGTON

David Arbo

Copyright © 2011 by David Arbo
ISBN 978-0-7385-8749-3

Published by Arcadia Publishing
Charleston, South Carolina

Printed in the United States of America

Library of Congress Control Number: 2010937740

For all general information, please contact Arcadia Publishing:
Telephone 843-853-2070
Fax 843-853-0044
E-mail sales@arcadiapublishing.com
For customer service and orders:
Toll-Free 1-888-313-2665

Visit us on the Internet at www.arcadiapublishing.com

This book is dedicated to Anne Spansel Arbo, my best friend and partner in life, without whom this book would not have been possible. Her assistance, patience, and support carried me through the process.

Contents

Acknowledgments		6
Introduction		7
1.	Pioneers, Settlers, and Stalwarts	11
2.	Churches, Schools, and Other Organizations	27
3.	Business and Commerce	59
4.	Trains, Boats, and More	87
5.	Rest, Relaxation, and Fun!	101
Bibliography		127

Acknowledgments

There are many people who have researched the history of Covington and have dedicated themselves to preserving the images and documentation that catalog that history. If I have met with any success with this volume, it is only because I have been able to utilize the fruits of their efforts. The one name that continually surfaced during my research was Norma Depriest Core. Her collection of documents, notes, and photographs are an invaluable resource to anyone wishing to see into the past of the city. Louis Wagner and Carol Jahncke are two others who were dedicated to chronicling the story of how Covington came to be. These people have provided a background that all future researchers will appreciate.

The present citizens of Covington are no less deserving of thanks both for their assistance with this collection and for the warm reception afforded me in putting together these images. The experiences and conversations I enjoyed with fellow amateur historians were enough to make the entire process worthwhile. I wish to thank Larry Smith and all the employees of Smith Hardware for allowing me access to their museum and photographs, which is where this project began. Thanks also to those who assisted with identification and factual details: Rusty Burns, Matthew Schlenker, and all the members of the Remember Covington group on the Internet. Their discussions helped illuminate many topics. And for all the others who contributed in any way: thank you for your support and encouragement.

The images in this book are courtesy of the people and organizations as noted. The following key is used for those with multiple entries: H.J. Smith Hardware (HJS), Howard Burns (HB), St. Tammany Parish School Board archives (STPSB), St. Tammany Parish Library (STPL), Pat Clanton (PC), Jeannie Marsolan and Phil Bazer (MB), Matthew Schlenker (MS), Freemasons Lodge No. 188 (FM), Richard Warner (RW), Chris Garcia (CG), Norma Core (NC), Genita Poole (GP), Georgene Wagner (GW), Covington Presbyterian Church (CPC), St. Paul's School (SPS), and St. Scholastica Academy (SSA).

Introduction

The story of Covington, Louisiana, begins with John Wharton Collins—the first person to lay out the plans for a city on the north shore of Lake Ponchartrain. Collins had followed his older brother William to New Orleans around 1800. Their father, Thomas Wharton, had adopted his mother's maiden name in America to escape notice of his pursuers from Scotland. (Apparently, his victory in a duel was not looked upon favorably by the loser's relatives.) A decade later, he found himself in another predicament as he was jailed during the Revolutionary War after having been declared a Tory. The evidence must have been doubtful, as his wife, Mary, was able to gain his release. George Washington is purported to have issued the pardon, and some stories state that he was infatuated with one of Mary's daughters, balancing the toddler on his knee as he heard the arguments for her husband's release. Thomas died in 1790, and Mary eventually settled her family in New York, which served as the port of embarkation for the Collins brothers' eventual trip to New Orleans, Louisiana.

John Wharton Collins had been working as a merchant for several years when he purchased a tract of land from Jacques Dreux in 1813. Collins then proposed the establishment of the town of Wharton on July 4 of that year. Collins was the architect of one of Covington's most unique features, the ox lot. An ox lot is a small corral in the center of a city block reserved for the temporary holding of cattle used to bring goods to market. Although other towns used ox lots in their design, Covington is one of the few to retain this feature. Today's citizens use these areas for parking cars, the modern version of the oxen of Collins's time.

Unfortunately, Collins died in 1814, having never seen his city become a reality. In fact, the early leaders of the community met in 1816 to change the name. On March 11, the Louisiana State Legislature passed an official act declaring the town as Covington. The more credible and accepted explanation for this name change is that it was done to honor Gen. Leonard Covington, a hero of the War of 1812. A more-colorful rendition, still accepted by some as the truth, is that the town gained its name out of respect for the fine Bourbon whiskey enjoyed by the community's early leaders, which was produced in Covington, Kentucky. Either way, the city that has graced the area has been called Covington since that time.

It was less than a year after Collins's death that his town began leaving its mark on historic events of the area. Gen. Andrew Jackson marched his troops through the area on his way to defend the country against the British in the famed Battle of New Orleans. The engineer of the brigade, Maj. H. Tatum, described passing through the town of Wharton situated on the Bogue Feliah River [sic]. He characterized the settlement as "a small new town containing but a few ordinary buildings." He also noted the small ships in the river that ferried goods and people to New Orleans.

The area also supplied some of the soldiers for the American forces during the War of 1812, although most of them did not see action. Gen. David Bannister Morgan, of the nearby town of Madisonville, engaged the British on the west bank of the Mississippi River while providing

protection for Jackson's troops. Morgan's daughter, Josephine, would later marry William Lancaster, brother of the daughter-in-law of John Wharton Collins.

Covington is the judicial seat of St. Tammany Parish, which originally covered a larger area. Washington Parish and Tangipahoa Parish were later created from parts of St. Tammany. The courthouse and jail were originally located in the city of Enon, about 20 miles northeast of Covington, when the parish was first established. A subsequent commission later moved the justice center to a site in the city of Claiborne, where the Claiborne Company financed and built a new courthouse. A few years later, the courts were again moved, this time to Covington, as the city of Claiborne did not prosper according to plans. The first Covington courthouse was built on Boston Street in 1830 and was replaced by a more modern building at the same location in 1950. The present facilities at 611 Columbia Street were constructed in 2003.

The original commerce of Covington centered on the town's pine trees, which are still a signature of its environment. Early settlers harvested the resin of the trees to produce pitch and tar, much of which made its way to Madisonville for use in shipbuilding. There are numerous references in legal documents (lawsuits, wills, etc.) referring to the products and tools for this industry for various parts of St. Tammany Parish. Although it is often difficult to identify the exact location where this work was done, the activities were spread across the parish and certainly included the area of Covington. Records also indicate an abundance of farming and agriculture, which would be expected to support the industry and the population in general. Brickyards also populated Covington and the surrounding area, finding success in the clay of the soil. Although some ships were built in Covington, their number was few compared to those made in other parts of St. Tammany Parish.

The enterprises mentioned above had lessened considerably by the early to mid-1800s and were replaced primarily by business in transportation. Covington was uniquely situated between New Orleans and the cities and states to the north, and many citizens capitalized on the situation. Large amounts of cotton were processed through the city on the way to Lake Ponchartrain and the larger city of the south shore. Various ships and schooners maintained a high level of commerce on the Bogue Falaya River, creating a vibrant center of activity at the landing at the foot of Columbia Street. Many new roads were constructed in and around Covington as this trafficking of goods continued to increase. Covington and its citizens were enjoying growth and prosperity, but it was not to last long.

The advance of the railroads began to affect Covington in 1854 with the completion of a line from New Orleans to Jackson, Mississippi, around the west end of Lake Ponchartrain. This circumvention of the town had an immediate effect, as it was quicker and cheaper to ship by rail than to use the roads and waterways that had been the tools for Covington's economic boom. Although it took several years, people eventually adjusted to the new situation, largely by reverting back to agriculture to provide for themselves. Folks had seemingly come to terms with the new situation when their economy was dealt a second blow by the start of the Civil War.

New Orleans surrendered to Union forces roughly one year after the war began, which brought the already dwindling trade with Covington to a complete halt. Although Covington itself voted to remain loyal to the Union, the townspeople nonetheless embraced their new country when Louisiana seceded. Several units of the Confederate army were mustered from the local population, with many seeing battle and some losing their lives in the conflict. The war dragged on, and hardships intensified, which led to the smuggling of goods between Covington and New Orleans, with both sides struggling to control this illegal trafficking.

Covington itself did not see any major action during the war but was marked by some minor events. Three Confederate gunboats were evacuated from New Orleans before it was occupied by Union forces: the *Oregon*, the *Bienville*, and the *Carondelet*. All three were taken early in 1862 to the Bogue Falaya River, where they had all useful materials removed and were then sunk to prevent them from falling into enemy hands. Later during that same year, the Union sent the *Grey Cloud* on an expedition into the Tchefuncte and Bogue Falaya Rivers. Troops were put ashore a short distance south of Covington but marched through the area and the town in search of their

foe. Although they encountered some gunfire, there were no actual battles, since there were no organized units or appreciable number of Confederate soldiers in the area. The ship withdrew, and except for the continued smuggling, Covington finished the war in relative obscurity.

The end of the Reconstruction era also marked the end of Covington's era of economic decline. The railroads again became a major factor, but this time, they increased the financial standing of the town and its people. The building of new rail lines in the area made it possible for lumber operations to extend into areas of the surrounding parish, since the river was no longer the only method of transportation. Several railroads were constructed connecting Covington with sawmills and logging operations, and this allowed for continued growth during the late 1800s and early 1900s. The brick-making industry also prospered during this time, as the trains provided a faster method for transporting products. Both the local and national growth of this era helped the Covington economy as the demand for building materials increased.

The railroads did not completely usurp transportation by boat; vessels still crossed Lake Ponchartrain regularly to moor at the Covington landing. Perhaps the most famous vessel to dock there was the *New Camelia*, joined by the likes of the *Josie*, the *Alice*, and the *Rosa A*. One of their main cargoes was people, because Covington, throughout its existence, has been a destination for rest and relaxation. Many a visitor has been hypnotized by the fresh air and natural surroundings of the Covington area, and people have continued to travel to the area in good times and bad. The Covington environs have been lauded through the decades for their ability to restore and promote health for those who choose them as a retreat. New Orleans has always provided the majority of the vacationers, but there are some from further away who have sung its praises. People routinely sought refuge in the region from outbreaks of malaria, yellow fever, and other epidemics in the larger cities. The area earned the nickname "Ozone Belt" due to the freshness of the air as cleansed by the pine trees, and Covington has more than once been declared one of the healthiest places to live in America.

More recently, Covington has become the location for many summer homes and vacation retreats due to its picturesque setting. Scores of people can relate happy memories of visits to idyllic settings along the Bogue Falaya River, excursions to parks, and leisurely walks through the streets of a friendly town. Those who grew up in Covington will profess that there is no better place to spend one's formative years. The completion of the causeway bridge over Lake Ponchartrain in 1956 made it possible for people to commute to New Orleans for work yet continue to enjoy the benefits of life in Covington. And enjoy it they do. Covington's unique history and quiet beauty make life in its shadow a truly pleasurable experience.

One
Pioneers, Settlers, and Stalwarts

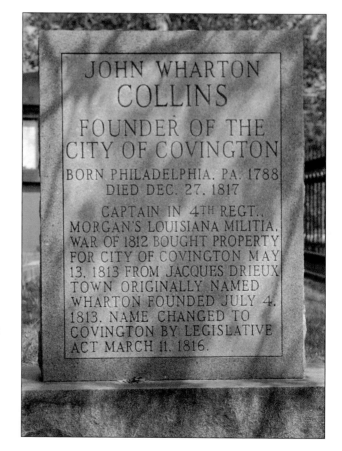

John Wharton Collins began the saga of Covington when he purchased land in St. Tammany Parish and laid out the town of Wharton. Although the name of the city did not last, his street design did, complete with the ox lots that Covington is known for. This marker for Collins's grave stands in the corner of Covington Cemetery No. 1 and notes the contributions made by the founder of the city. (Courtesy of the author.)

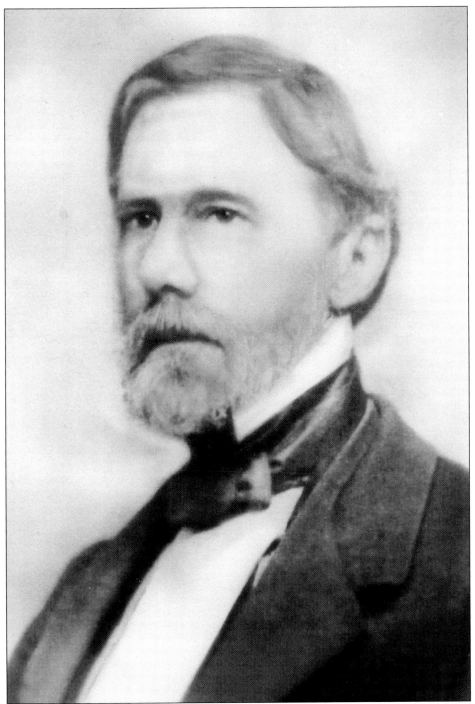

Thomas Wharton Collens was the son of Covington founder John Wharton Collins. The spelling of the last name changed and continued through subsequent descendants. Some descendants believe the new spelling was created to give the illusion of French ancestry when the family resided in New Orleans. Collens became judge of the Seventh District Court in New Orleans and established himself as a philosopher and author. (Courtesy of Cynthia Parham.)

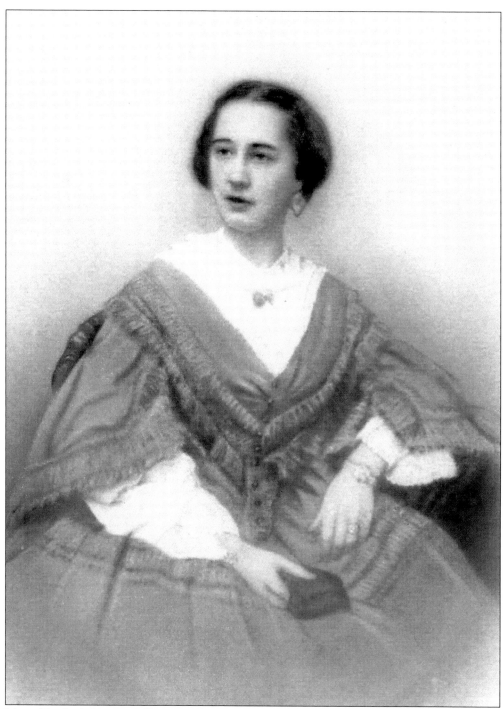

Maria Elizabeth Louisa Collens was the granddaughter of John Wharton Collins. She married Brisbane Marshall Turnbull, a relative of Daniel Turnbull, who established Rosedown plantation in St. Francisville, Louisiana, around 1830. (Courtesy of Cynthia Parham.)

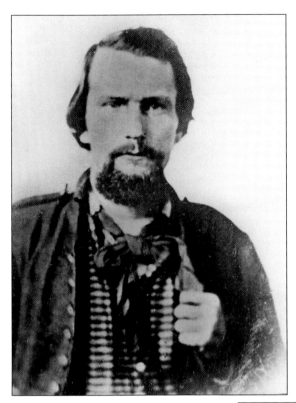

David Goodbee (1832–1872) was one of the early settlers of St. Tammany Parish and lived on the outskirts of Covington in what is now the town of Goodbee. His descendants spread throughout St. Tammany Parish and were involved in Covington commerce. (Courtesy of PC.)

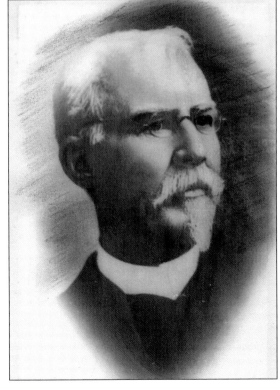

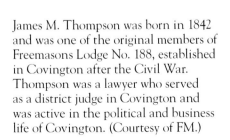

James M. Thompson was born in 1842 and was one of the original members of Freemasons Lodge No. 188, established in Covington after the Civil War. Thompson was a lawyer who served as a district judge in Covington and was active in the political and business life of Covington. (Courtesy of FM.)

Milton Burns (1846–1917) was the eldest child of John Burns and Harriet Redditt, who came to the Covington area in 1840 and settled in the area known as Chubby Hill. The descendants of this couple can be found in literally every corner of Covington; many claim a relation to this pioneer family of the area. Burns family members have been active in the business, politics, and education of Covington for generations. One of the more endearing landmarks for many who grew up in the 1960s and 1970s was the Burns Furniture Store, which had its beginnings in the J.C. Burns Mercantile Company. (Courtesy of FM.)

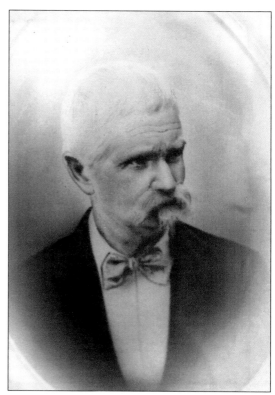

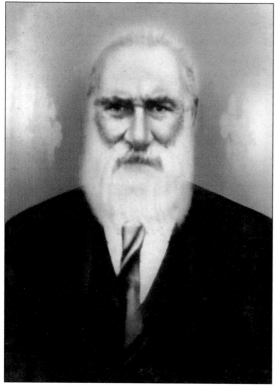

William Colson Warren (1823–1895) was a relatively prosperous farmer and grocer who came to Covington from Mississippi some time during the 1840s. (Courtesy of FM.)

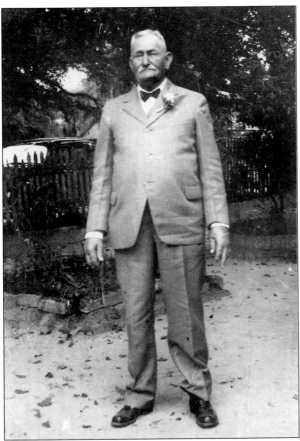

Emile "Boss" Frederick (1857–1945) was mayor of Covington in 1891 and 1892. He was one of the more colorful and memorable citizens of Covington as well as one of the most respected. His descendants continue to be a part of the fabric of the town. (Courtesy of PC.)

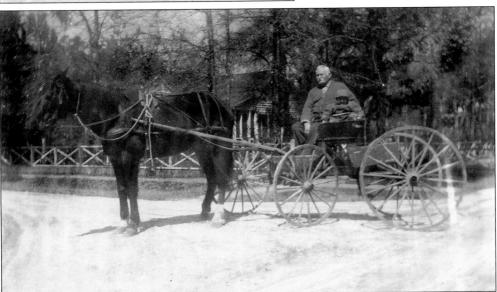

Emile "Boss" Frederick never did take to the automobiles that became the standard method of transportation of his day. He was frequently seen riding into town in his horse-drawn carriage with a faithful dog at his side. (Courtesy of PC.)

Emile "Boss" Frederick was prominent in Covington politics and business during the late 1800s and early 1900s. He married Amy McManus in 1891 and had a beautiful new home constructed on Vermont Street as a wedding gift. The story goes that the house was a surprise for his bride, and the townspeople had many conversations discussing why the 34-year-old bachelor was building such a large home. Many descendants of this union still live in Covington today. (Courtesy of PC.)

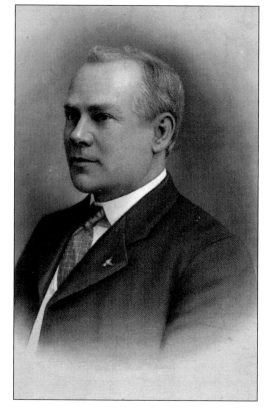

Joseph B. Lancaster (1865–1916), was a state legislator, district attorney, and judge. He was superintendent of education for St. Tammany Parish from 1900 to 1904 and is credited with many reforms to improve learning in the area. Lancaster Elementary School, scheduled to open for the 2011–2012 school year, is named in his honor. Lancaster was the grandson of Gen. David Bannister Morgan, who fought in the Battle of New Orleans and was prominent in the early days of Covington and St. Tammany Parish. (Courtesy of CG.)

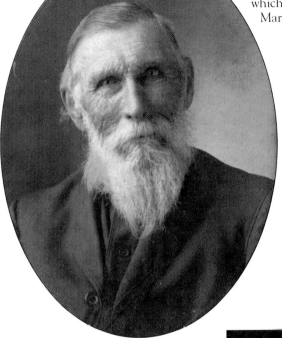

William Farr Depriest (1837–1915) came to Covington from Mississippi during the mid-1800s. He started out as a farmer and then opened a boardinghouse, which he ran for about 30 years with his wife, Mary. (Courtesy of NC.)

Mary Cooper Depriest (1846–1918) lived her whole life in St. Tammany Parish. Her mother, Tabitha Mayfield, was an early native of St. Tammany Parish, born near Covington in 1817. Mary was betrothed to William Depriest in 1867, and they had several children, including Ulysses (page 65) and Minnie (page 82). (Courtesy of NC.)

John Coltora was born in 1876 in Mississippi. The son of Italian immigrants moved to Covington, where he was a saloon operator in the early 1900s. (Courtesy of NC.)

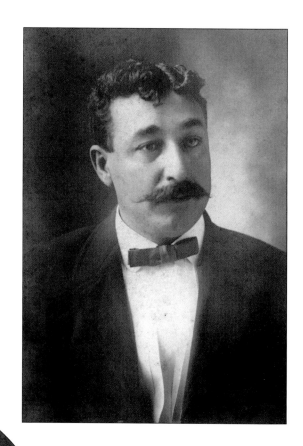

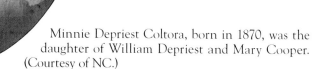

Minnie Depriest Coltora, born in 1870, was the daughter of William Depriest and Mary Cooper. (Courtesy of NC.)

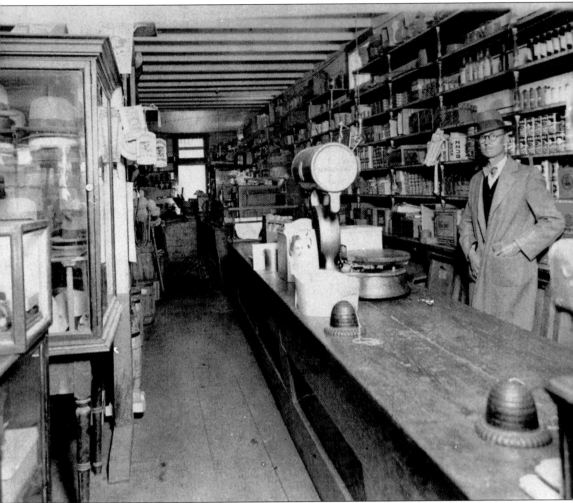

John Louis "Deed" Smith stands behind the counter in the old store, which today has been converted into a museum of nostalgic bits of odds and ends from days gone by. This view is looking toward the rear of the building on the right side. The many shelves were packed with merchandise then, just as today they are packed with mementos of old. (Courtesy of HJS.)

This house was the home of the Weaver family. Henry T.G. Weaver lived here with his wife, Josie. Their son, Dudley Huitt Weaver, was the captain of the *Josie*, which made many excursions along the Tchefuncte and Bogue Falaya Rivers. (Courtesy of NC.)

Elmer Eugene Lyon was born in 1874 in Vermont but moved to Covington along with his parents. He eventually became the superintendent of schools for St. Tammany Parish and held that position from 1911 to 1937. He was such a respected and beloved figure that Covington High School was renamed in his honor while he was still living. (Courtesy of Meredith Lyon Ramke.)

J.H. Warner was secretary-treasurer of Mackie's Pine Products and also for its successor, Delta Pine Products. He served as president of the St. Tammany Parish School Board and also as president of the St. Tammany Parish Fair Association. His home on Twenty-first Avenue was the location of the unique pine-arch entranceway. Prior to settling in Covington, Warner had worked as an overseer at Destrehan plantation in St. John the Baptist Parish. (Courtesy of FM.)

Morris H. Talley, born in 1846, was a local farmer and businessman in the Covington area and was involved in the early growth of Masonic Lodge No. 188, which was chartered shortly after the Civil War. The Talleys are one of the older families of the area, coming to St. Tammany Parish around 1800. (Courtesy of FM.)

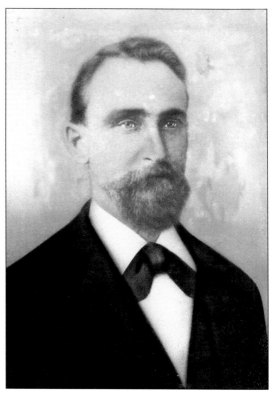

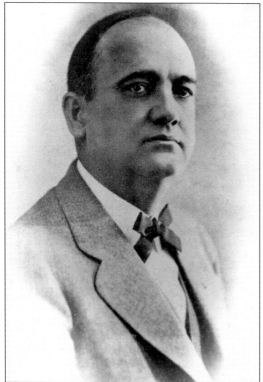

Dr. Hezzie David Bulloch, born in 1883, was a physician who began practice in Folsom and then moved to Covington in 1917. He was the parish coroner from 1916 to 1924 and was also active in political and civic organizations. (Courtesy of FM.)

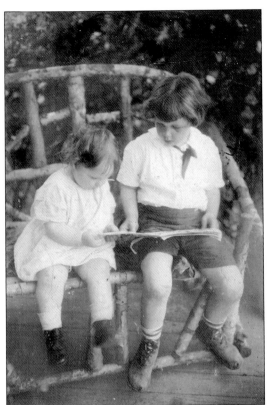

Rosemary and brother Brandon Fuhrman share a book around 1925. Brandon fought in the Pacific during World War II and managed to survive the Bataan Death March but died later in the war. Rosemary went on to enjoy a successful career in entertainment—as did her father, Sidney Fuhrman. Emile "Boss" Frederick was the siblings' grandfather. (Courtesy of PC.)

Community leaders pose for a photograph around 1910. The ribbons read "Commission." Shown here from left to right are (sitting) Anatole Beaucoudray, Julian Smith, Boy Warren, Clarence Shonberg, and unidentified; (kneeling) ? Galouye and ? Loyd; (standing) H.R. Planche, Leon Hebert, Warren Thomas, Emile Beaucoudray, Dr. F.G. Marrero (mayor 1910–1914), Deed Smith, unidentified, Fortune Planche, Lewis Morgan, and unidentified. (Courtesy of NC.)

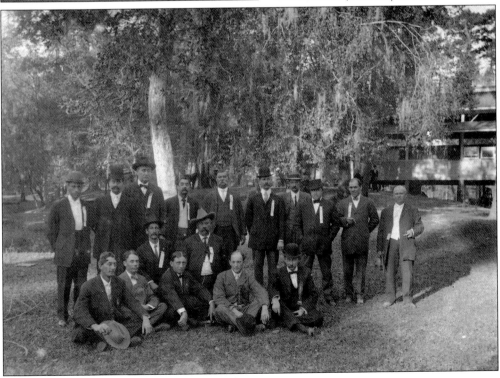

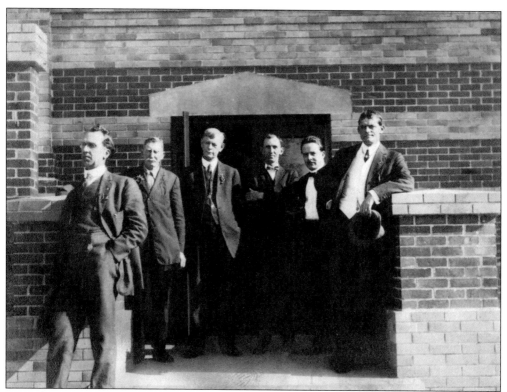

Several community members active in education pause during a school visit at the Covington Grammar School in the early 1900s. From left to right are Elmer Lyon, Emile Frederick, Charles Liddle, A.J. Park, N.H. Fitzsimmons, and unidentified. (Courtesy of NC.)

Norma Depriest Core was descended from a long line of Covington natives. She was an avid historian and organized an extensive collection of old documents and photographs, many of which appear in this book. She was a well-known member of the local historical society, and, as one story goes, she rescued hundreds of old images and papers that had been set on the curbside for trash pickup when the old courthouse was demolished in 1950. (Courtesy of NC.)

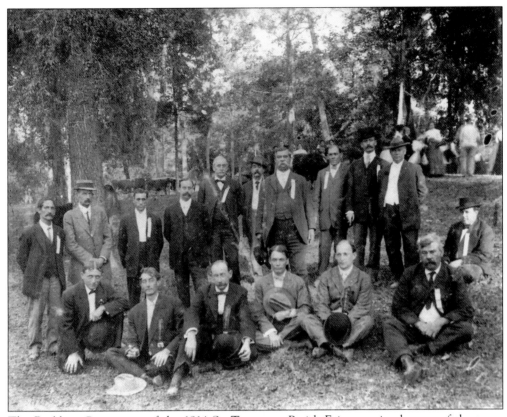

The Building Committee of the 1914 St. Tammany Parish Fair contained many of the town notables of the day. From left to right are (first row) H.J. Warren, Anatole Beaucoudray, ? Sanders, Julian H. Smith, C.E. Schoneberg, Paul Laborde, and Paul Lacroix; (second row) two unidentified, Maurice P. Planche, Leon Hebert, H.R. Warren, Emile Beaucoudray, Dr. Marrero, Louis Morgan, J. Louis "Deed" Smith, and J.B. Lancaster. (Courtesy of HJS.)

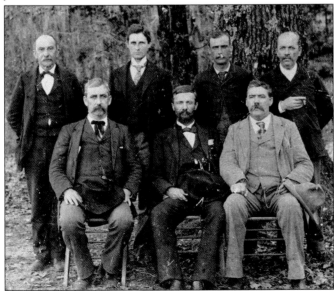

Harrison Rankin Warren (seated far left) and Paul Laborde (seated far right) are pictured with unidentified contemporaries. (Courtesy of HJS.)

Two

Churches, Schools, and Other Organizations

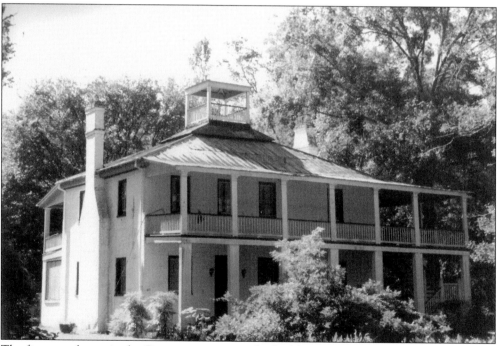

The first courthouse in the Covington area was this building on land donated by the Claiborne Company. The original parish seat and courthouse were in the town of Enon. The company established the town of Claiborne across the river from Covington, and the courthouse donation was designed to promote the town. This strategy failed, as the area never gained prominence. This land eventually became part of the city of Covington, although the area is still known as Claiborne Hill. (Courtesy of Norcom Jackson.)

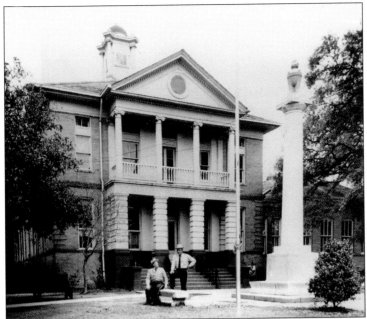

This building was the second courthouse in Covington and was built in 1830. It served as the seat of justice for St. Tammany Parish for over 100 years. It was a landmark in downtown Covington and was the scene of many of the events that shaped the city and the parish. (Courtesy of Martha Dutsch.)

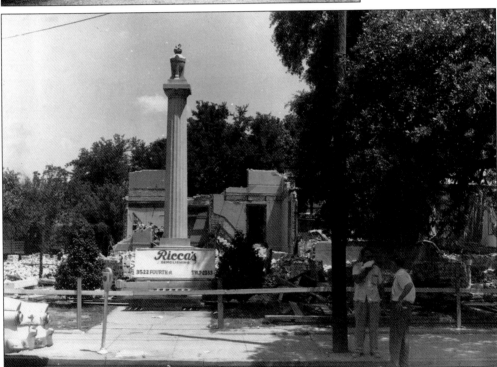

The original courthouse building on Boston Street was demolished in 1950 for a newer, more modern-looking building. Many people wished the building could have been renovated and preserved. It would certainly be an impressive historic building today if that had been accomplished. The memorial column shown here is still in place on Boston Street, along with the courthouse building constructed in 1950. The most recent courthouse was built in 2003 and is located at the corner of Columbia Street and Jefferson Avenue. (Courtesy of NC.)

St. Peter's Catholic Church has been in Covington since 1843, when it was established through the efforts of Abbet Jounanneau and Bishop Antoine Blanc. The congregation has worshiped in three churches during its existence in Covington. The first church was near the banks of the Bogue Falaya River. The structure seen here, the second church, was constructed about 1892 at the corner of Massachusetts and Rutland Streets. St. Peter's was served by priests of the Order of St. Benedict until 1992, when it came under the auspices of the Archdiocese of New Orleans. (Courtesy of NC.)

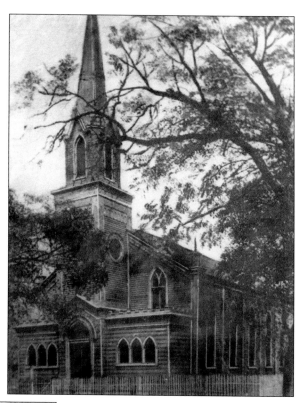

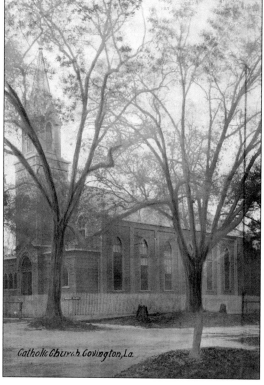

A closer view shows St. Peter's Church nestled among the oak trees on Jefferson Avenue. Notes on the reverse of the photograph state it was taken on a wedding day, but the participants' names are unknown. (Courtesy of MB.)

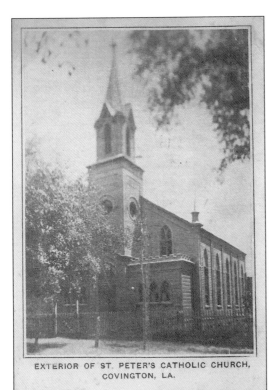

EXTERIOR OF ST. PETER'S CATHOLIC CHURCH, COVINGTON, LA.

This view shows the steeple from the front of St. Peter's Church. This building was used until 1940, when the current structure on Jefferson Avenue was built. The older one was taken apart and rebuilt at the corner of Columbia Street and Tyler Street, where it became the Holy Family Church. The cross on display at this same street corner was reportedly atop the steeple of Holy Family Church. (Courtesy of MB.)

Some of the clergy of St. Peter's Church pose with Archbishop Rummel and other members of the Archdiocese of New Orleans after a confirmation ceremony in May 1936. Seen here from left to right are (first row) Fr. Bernard Keating, Fr. Odilo Alt, Fr. Othmar Bleil, and Fr. Anthony Wegmann; (second row) Fr. Columbian Wenzel, Fr. James Erikson, Archbishop Joseph Francis Rummel, and Abbot Columbian Thuis; (third row) Fr. Julian Martinez and Fr. Placid Dobyns. (Courtesy of HJS.)

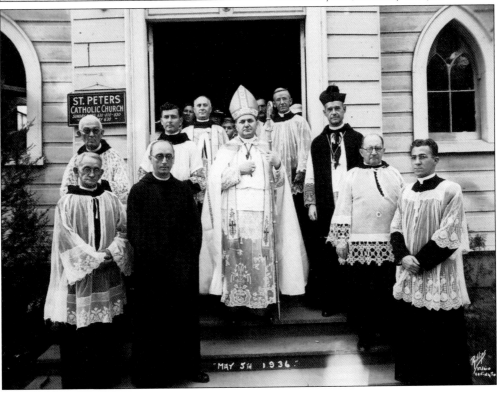

St. Joseph Seminary College (St. Benedict College) is a seminary established in 1891. The Benedictine monks of St. Joseph Abbey maintain the school within the dioceses of New Orleans and Mobile. The abbey and school were moved to their present site on the Bogue Falaya River in 1902 and were officially chartered in 1903. A fire in 1907 resulted in new buildings, which were themselves replaced in the 1950s to accommodate the growth of the school. St. Joseph's Abbey sits on a beautiful piece of land graced with pine woods, and it continues to graduate future Roman Catholic priests. (Courtesy of SPS.)

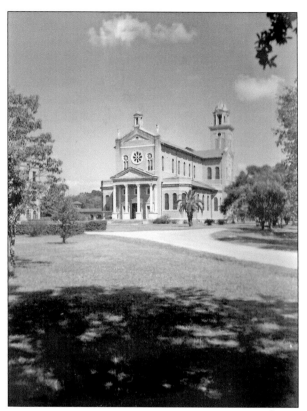

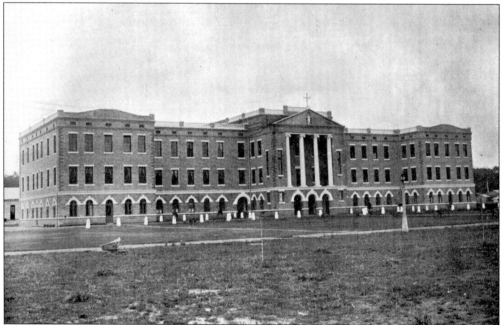

This seminary building replaced the original St. Joseph's Seminary, which succumbed to flame. The area of the school has been designated as St. Benedict, Louisiana, leading local residents to refer to the facility as St. Ben's College. (Courtesy of SPS.)

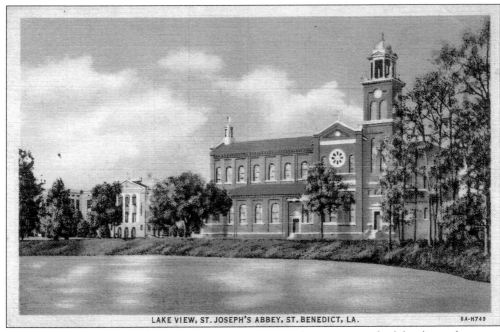

LAKE VIEW, ST. JOSEPH'S ABBEY, ST. BENEDICT, LA.

A view across the lake shows the peaceful setting of St. Joseph's Abbey. (Courtesy of MB.)

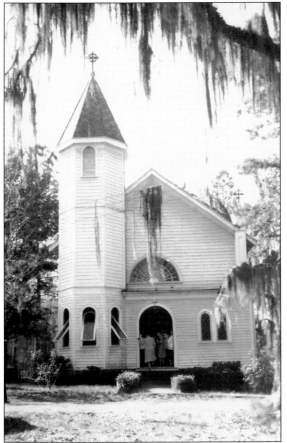

The current chapel of Christ Episcopal Church served as the congregation's first church, having been built in 1846 by Jonathan Arthur, who came from England. The bell tower was added in the 1880s, and the altar was installed around 1900. This structure lays claim as the oldest building in continuous use in Covington. A new brick church, built in 1967, stands guard at the entrance to Bogue Falaya Park on New Hampshire Street. (Courtesy of Christ Episcopal Church.)

The Reverend Shaw is pictured on the steps of Christ Episcopal Church about 1940. This building currently serves as the chapel for daily services and special ceremonies such as weddings, baptisms, and funerals. (Courtesy of HB.)

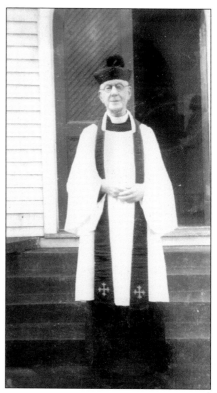

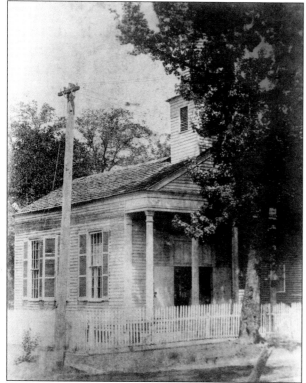

The Covington Presbyterian Church had its beginnings in 1878 with the reopening of this structure as a house of worship at the corner of New Hampshire Street and what is now Independence Street. The original Presbyterian services were held in this building in 1848. However, it was dormant for many years before the reopening. (Courtesy of CPC.)

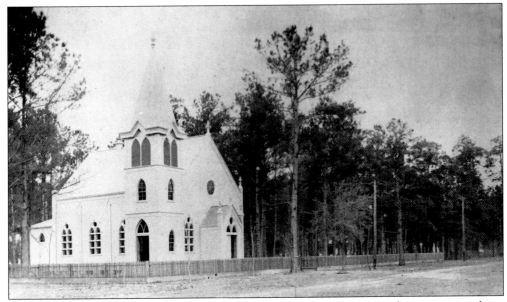

Land was purchased for a new church, and it was completed in 1903. Several improvements have been added through the years, but the congregation has met in this same building on Jefferson Avenue for over 100 years. (Courtesy of CPC.)

The Covington Presbyterian Church received this addition as the congregation continued to grow. (Courtesy of CPC.)

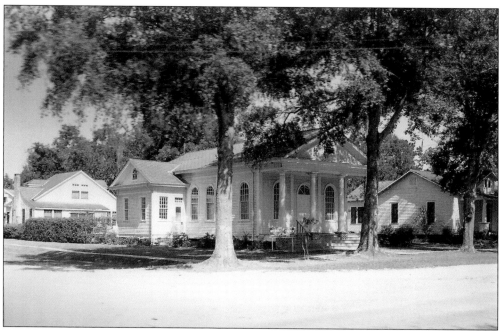

The Covington Methodist Church, shown in this photograph, was located on Jefferson Avenue where the current Methodist church stands today. (Courtesy of MB.)

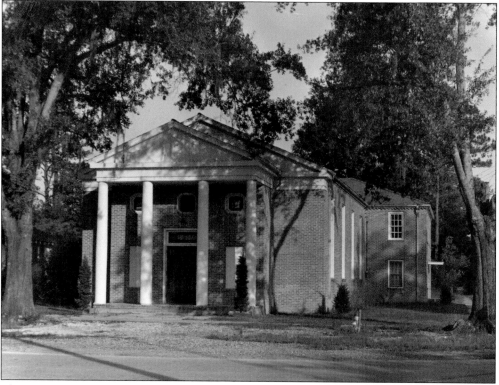

The First Baptist Church of Covington sits tranquilly on Jefferson Avenue. This structure still stands; it is now part of the St. Tammany Parish Board of Education building. (Courtesy of MB.)

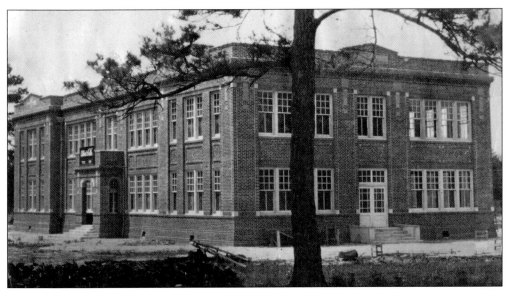

This image shows the old Covington High School building at the location currently occupied by William Pitcher Junior High School on Jefferson Avenue. The school opened in 1925 and was soon renamed Lyon High School in 1928 to honor superintendent of schools Elmer E. Lyon. However, the name was changed back to Covington High School in 1945, since state law prohibited it from being named after a person still living. This building was razed by fire in 1974, even as the new school building was under construction. Temporary facilities were used until moving to the new school on Highway 190 the following year. This photograph shows the newly built school before the cupola was added. (Courtesy of STPSB.)

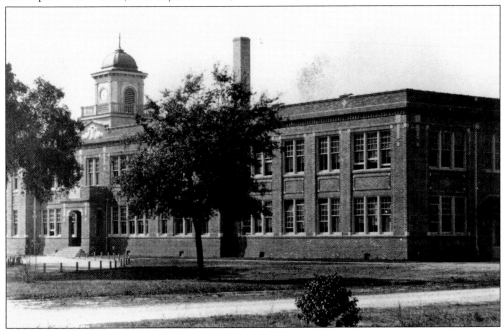

This front view of Covington High School shows the completed bell tower and lock. The young oak trees seen in the foreground would grow to majestically frame the entrance to the school. (Courtesy of STPSB.)

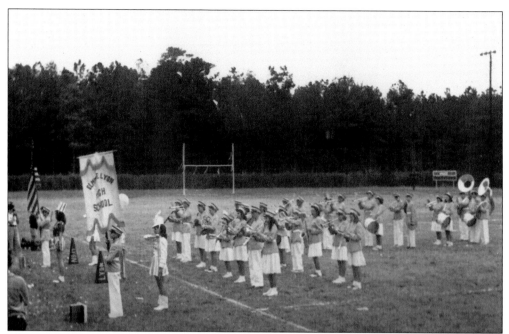

The marching band of Lyon High School practices for an upcoming halftime routine. (Courtesy of HB.)

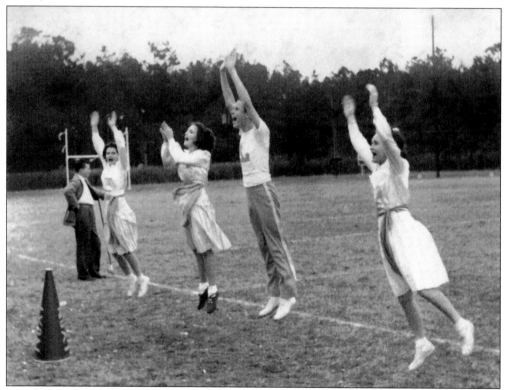

Lyon High School cheerleaders practice for an upcoming football game around 1939. (Courtesy of HB.)

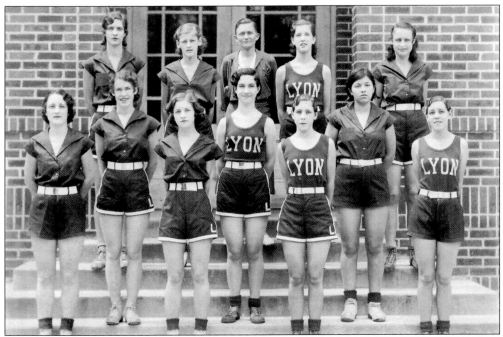
Here is the 1932 Lyon High School girls' basketball team, coached by Carmen Beal. From left to right are (first row) Lucille Hymel, captain Beauty Smith, Marian ?, Muriel Gautreaux, Lois Poole, Verda Jones, and Iris Poole; (second row) Evelyn Thomas, Hermanie Depriest, coach Carmen Beal, ? Fontenot, and Lena Pearl Kervin. (Courtesy of GP.)

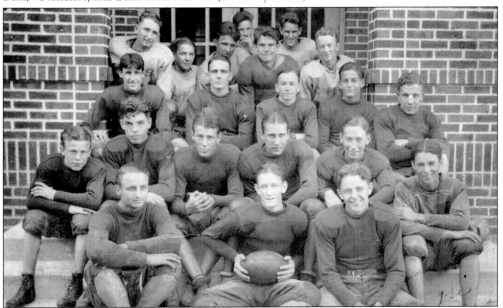
The 1927 Covington High School football squad poses for a team photograph. Included in the picture are Sam Blossman (first row, second from left), Alvin Ross (first row, third from left), Albert David (second row), Giles Pennington (second row), Jesse McLain (third row, second from left), Frank "Fritz" Burns (third row, fourth from left), and Robert Dutsch (third row, fifth from left. The rest are unidentified. (Courtesy of HB.)

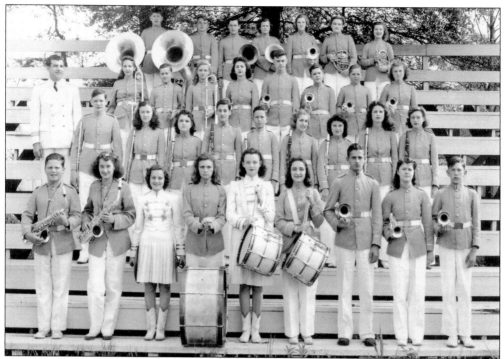

The 1942 Lyon High School band was led by a Mr. Zinna. Seen here from left to right are (first row) Cyp Schoen, Katherine Toups, Margaret Addison, Marguerite Sharp, Hilda McGee, Joe Ellen Heintz, Bobby Matranga, Gloria Bradbury, and Fred Terry; (second row) Harold Burns, Gerry Abney, Wilmuth Burns, unidentified, Cyril Cleland, Cleo Stanga, Ailene Foucheaux, Rita Stire, and Cloa Holden; (third row) Mr. Zinna, Elizabeth Malone, Billy Burns, Dorothy Heath, Eunita Whelpley, Albro Blair, Donald Kerr, Earl Heath, and Louise Anderson; (fourth row) Troy Jackson, Ralph Menetre, Lloyd Koepp, Gaynelle Knight, Doris Ball, Norma Overby, and Katherine DuBerry. (Courtesy of HB.)

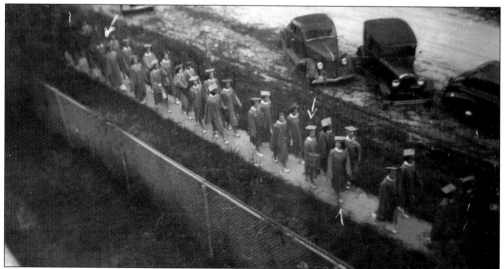

Members of the 1942 senior class of Lyon High School are seen processing to their graduation ceremony. (Courtesy of HB.)

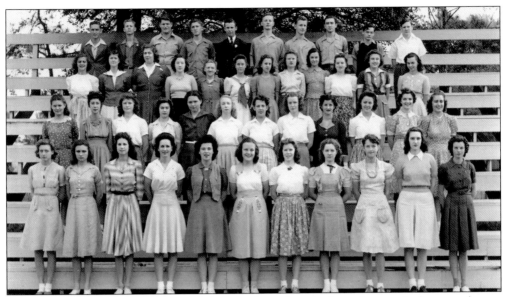

The 1942 graduating class of Lyon High School stands proudly as they await the next chapter in their lives. From left to right are (first row) ? Holden, Margaret Sharp, Rita Stine, Erma Lee Russell, June Koepp, Madeline Dunn, Audrey McMurray, Ellen Simmons, Cora Findley, Jo Alice Bougue, and Elaine Magee; (second row) Elizabeth Schroder, Gloria Bischoff, Dorothy Jenkins, Hazel Kennedy, Margi O'Keefe, Betty Hard, Alta Williams, Kappy Roseau, Ollie Ball, Helen Sandifer, Mary Phillips, and Dorothy Watts; (third row) Virginia Lelong, Gloria Bradbury, Meda Koepp, Lois "Puddin" Lacroix, Evelyn Taylor, Eula Kennedy, Anna Lowe, Joyce Davenport, Muriel Erwin, Janice Pierce, Mildred Werhli, and Lorraine Lester; (fourth row) Lawrence Peters, Sidney Grantham, Flasdick Hawkins, Sidney Huval, Aaron Fitzgerald, Jack Lee, Zack Lee, Alex Ferrer, Frank Shortridge, and Harold Burns. (Courtesy of HB.)

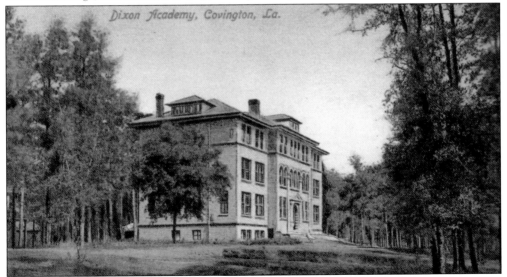

Dixon Academy was originally a private school that eventually became St. Paul's Academy. The original building on the site continued to be used by St. Paul's and was called Dixon Hall. This structure burned in 1981, but some of the bricks were salvaged from the rubble and used to create a courtyard in the area known as Founder's Circle. (Courtesy of SPS.)

The *Dixonian* was a yearbook-type publication for Dixon Academy that contained advertisements and descriptions of courses offered by the school. (Courtesy of SPS.)

Dixon Academy opened in 1907 but failed after only a short time. The institution was then purchased by Benedictine monks from St. Joseph's Abbey and reopened as St. Paul's Academy in 1911. The school succeeded after developing an excellent reputation as "St. Paul's among the pines." (Courtesy of SPS.)

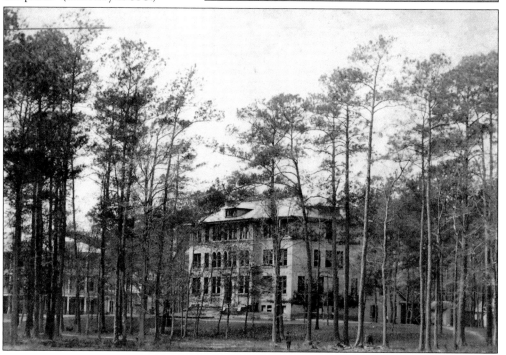

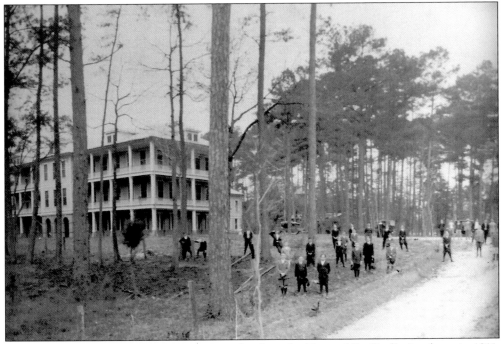

Students stand among the pine trees near the dorm building of St. Paul's Academy in 1911. (Courtesy of SPS.)

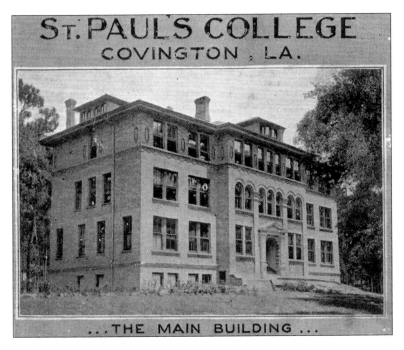

The school changed hands again when the Benedictines felt the need of other obligations and the property was purchased by the Christian Brothers. The school had come to be known as St. Paul's College, and that name remained at the time of this exchange in 1918. (Courtesy of SPS.)

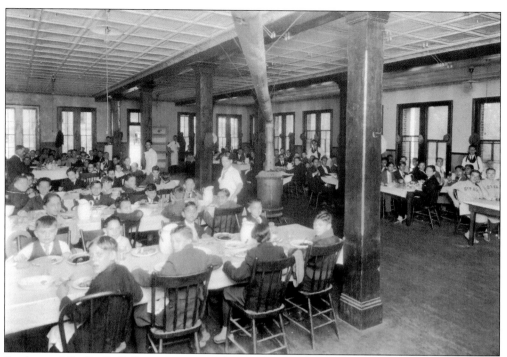
Students of St. Paul's College enjoy a midday meal in the cafeteria in 1923. (Courtesy of SPS.)

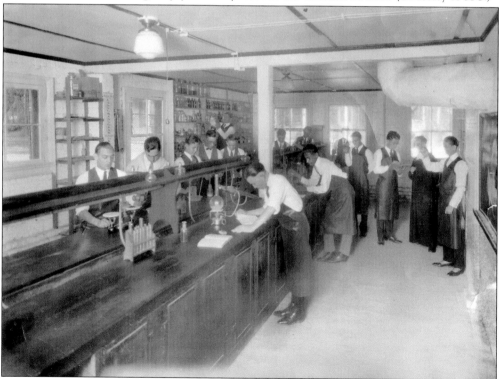
Several courses of study were offered at St. Paul's, including classical, academic, and commercial. Here students use experimental equipment during a science class. (Courtesy of SPS.)

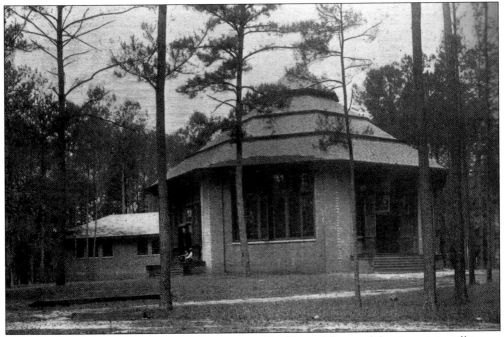

The school's original gymnasium was an octagonal building. After modifications, it is still in use today as an auditorium with a stage where today's students perform drama productions. (Courtesy of SPS.)

St. Paul's College was originally designed to teach high school students only but eventually added grades of all ages. Today, the school has returned to a high school–only format. (Courtesy of SPS.)

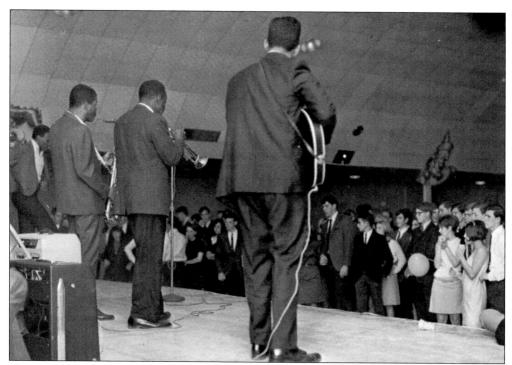

High school has always been marked by the popular music of the day for all students, and it was no different for the boys of St. Paul's School in the 1960s. This dance was held in what was then the school gym. The singer on the far left is a young Aaron Neville. (Courtesy of MS.)

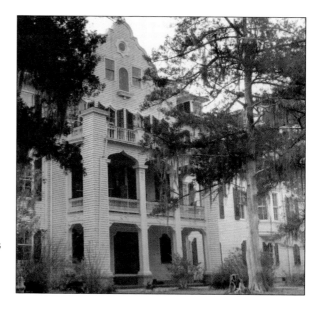

St. Scholastica Academy opened in 1903 as a private all-girls Catholic high school and continues the same educational mission today. The academy was founded by nuns of the Benedictine order, the sister organization of the monks of St. Joseph's Abbey. St. Scholastica continues to maintain a close relationship with the abbey, although the Benedictine nuns relinquished operation of the school to the Archdiocese of New Orleans in 1967. The bell that announced the opening of the school over 100 years ago still survives and continues to ring at the commencement ceremony of a new graduating class each spring. (Courtesy of SSA.)

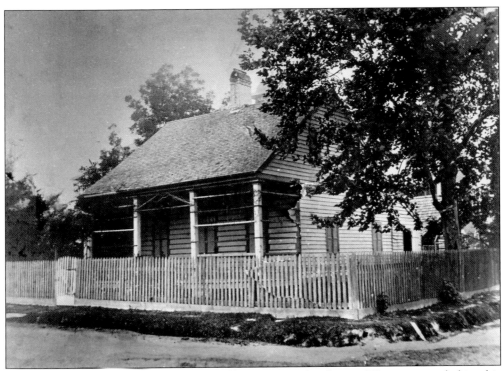

The first Benedictine convent was a smaller, more modest house. The nuns resided in this building until they were able to move to the larger building that included the school. (Courtesy of SSA.)

The old gym and the surrounding yard provided the site for the students' physical education classes. (Courtesy of SSA.)

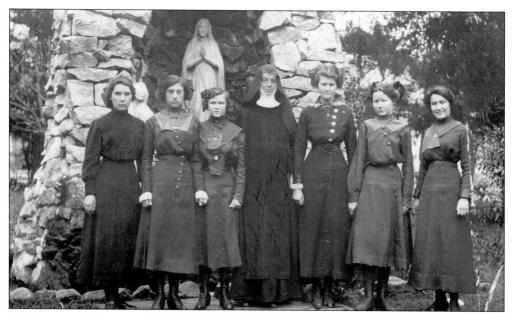

Sr. Florentine Yokum stands with her shorthand/typing class in front of the grotto on the St. Scholastica Academy campus. When the original school and convent building was demolished, this grotto became the oldest structure on campus, since it has been on the grounds since the school's inception. Sister Florentine was elected prioress of the convent in 1921 and served in that capacity until 1937. (Courtesy of SSA.)

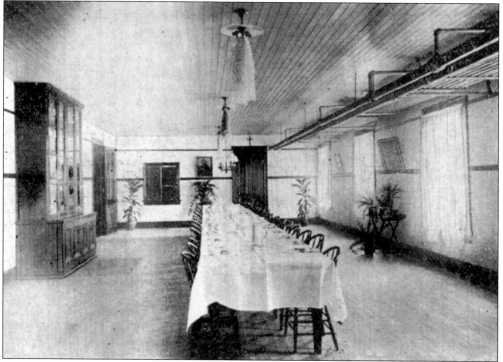

The dining hall or refectory, located in the school/convent building, provided an area for residents to take their meals. (Courtesy of SSA.)

The play room was used for drama productions as well as social events and recreational activities. (Courtesy of SSA.)

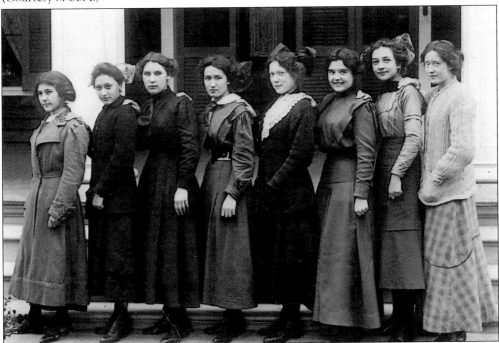

The members of the St. Scholastica Academy class of 1910 are, from left to right, Juanita Alfonso, Jeanne Piquet, Sophie Mire, Ferdie Cole, Ruth Frederick, unidentified, Cecile Warren, and Anna Frederick. (Courtesy of SSA.)

St. Scholastica students have some fun playing on the merry-go-round on the school grounds. (Courtesy of SSA.)

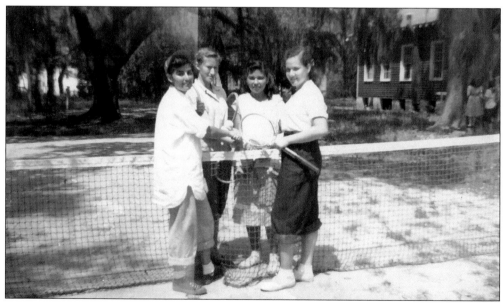

At one point, a tennis court existed on the grounds—as this photograph illustrates. (Courtesy of SSA.)

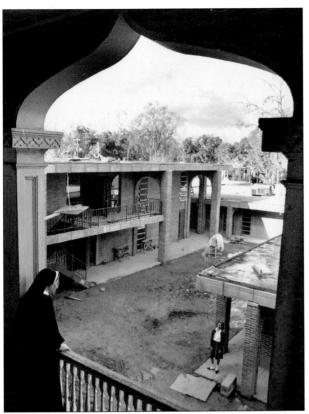

A Benedictine nun stands on the balcony of the old convent building as she speaks with a St. Scholastica student below. Construction of the new administration building is in the background. (Courtesy of SSA.)

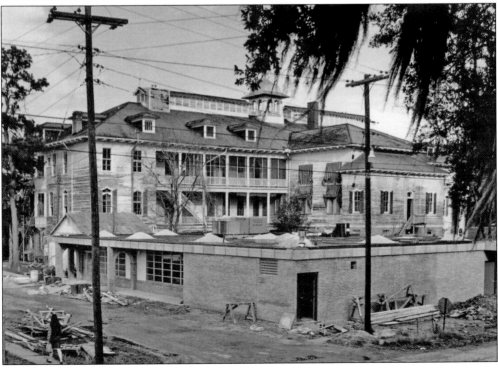

Construction of the St. Scholastica cafeteria in 1950 shows the orientation of the old convent and school building. This view is from Washington Street looking across Twentieth Avenue towards downtown Covington and the back of the convent. (Courtesy of SSA.)

Freida Kelly was a graduate of the first class of St. Scholastica Academy in 1905. (Courtesy of SSA.)

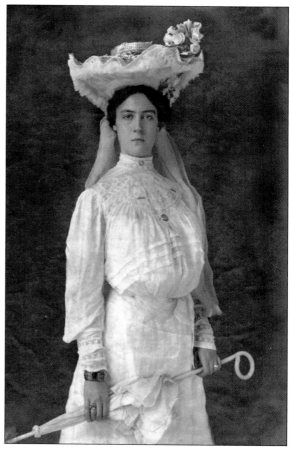

In the early days, St. Scholastica had plenty of room to grow, but space became more limited as Covington grew up around it. The old Benedictine convent and St. Scholastica Academy school building was an impressive three-story structure that unfortunately had to be torn down due to its instability. The school was on the left, and the convent was on the right. The photographer for this picture would have been standing near the corner of Boston and Vermont Streets. (Courtesy of SSA.)

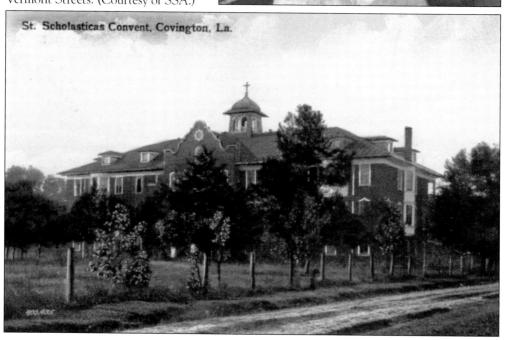

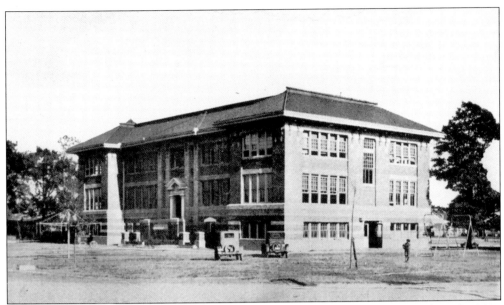

This postcard image shows the Covington Grammar School shortly after it opened in the early 1900s. The school originally encompassed all grades, including high school. (Courtesy of STPSB.)

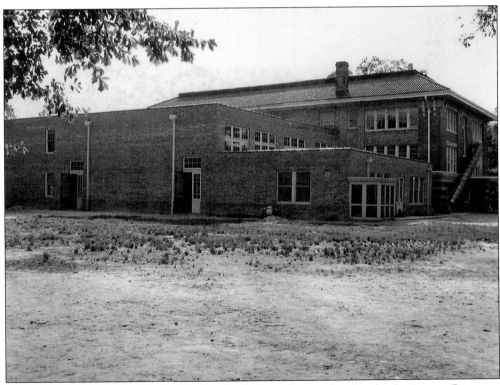

The older students were moved to a high school relatively soon, leaving the Covington Grammar School to the younger students. This view shows the later addition along with the famous fire escape chute. Students would look forward to fire drills, during which they would slide down the tube. It also helped that classes were temporarily suspended. (Courtesy of STPSB.)

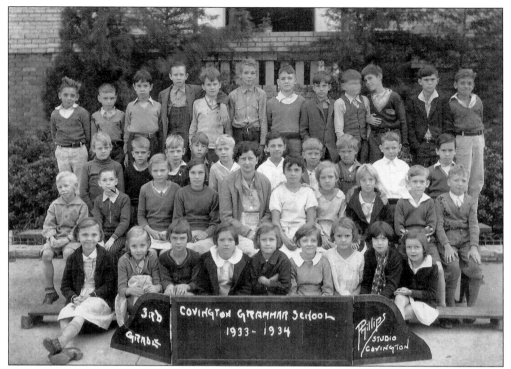
The 1933–1934 third grade of the Covington Grammar School poses in front of the school building for their class picture with their teacher, Hester Burns. (Courtesy of HB.)

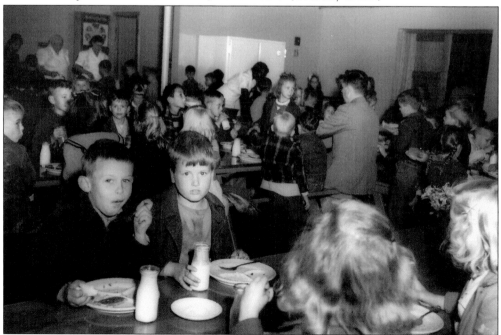
The name was changed to Covington Elementary School around 1940. Here students have lunch around 1941. The cafeteria was part of an addition to the original structure. (Courtesy of STPSB.)

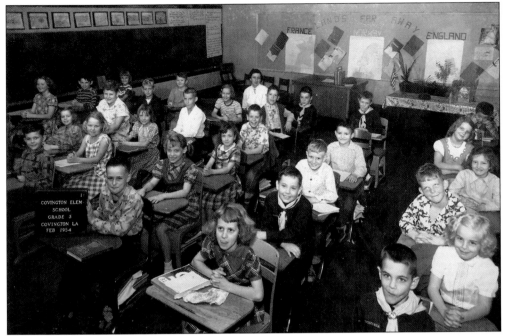

The 1954 Covington Elementary School third grade had their photograph snapped while sitting in their desks in the classroom. Dutch Hune was their instructor. (Courtesy of MS.)

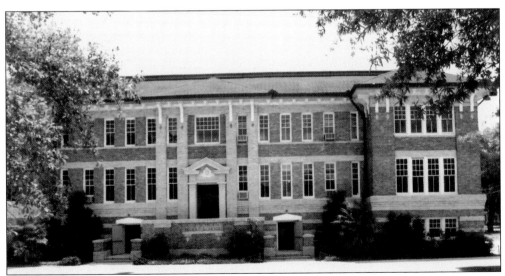

The building changed function again as it became C.J. Schoen Middle School. Lee Harvey Oswald, President Kennedy's assassin, attended school in this building for a short time. Recently renovated, the building now houses board of education administrative offices after undergoing extensive renovation. This structure has been part of education in Covington for over 100 years. (Courtesy of MS.)

The Covington Elementary School Band stands in front of their school. Notice how the bricks have been painted to resemble a keyboard. (Courtesy of RW.)

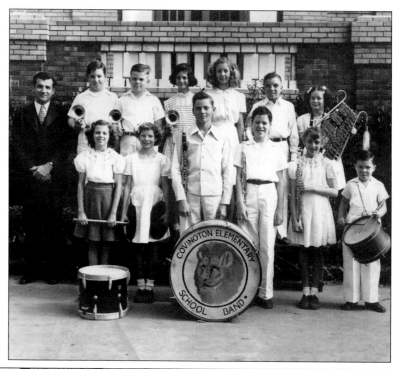

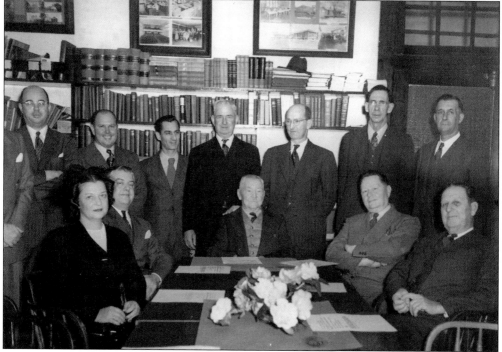

The 1947 St. Tammany Parish School Board takes a break from business to have a picture snapped. From left to right are (seated) Louise Baudot, Hubert Williams, Victor Davalier, Walter Jones, and Tom E. Brunnig; (standing) William Pitcher, Sidney Crawford, Eugene Matranga, Roy Mitchell, Bryan D. Burns, John Harper, and John Ouder. (Courtesy of Bryan Burns.)

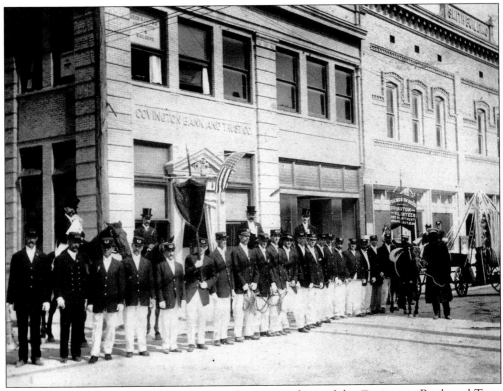

The Covington Volunteer Fire Department lines up in front of the Covington Bank and Trust building on the corner of Boston and Columbia Streets in 1908. There was a major fire in 1898, which sparked interest in creating a fire department. Interest apparently waned; after another fire in 1906, however, a more permanent organization was established. (Courtesy of HJS.)

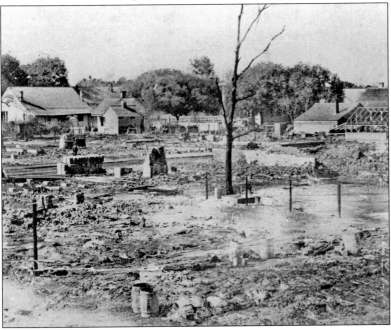

This photograph shows the charred remains at the corner of Rutland and Columbia Streets as a result of the 1906 fire. (Courtesy of HJS.)

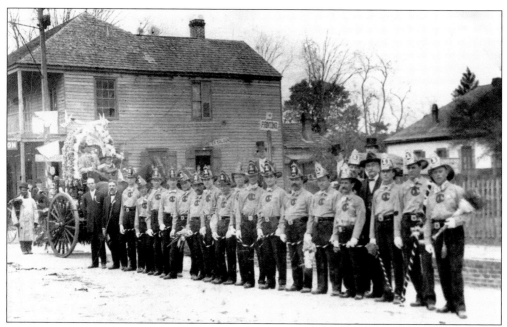

The Covington Volunteer Fire Department lines up for another display of its numbers and equipment. The sign in the background indicates how patrons can enter the saloon from the side entrance. (Courtesy of HJS.)

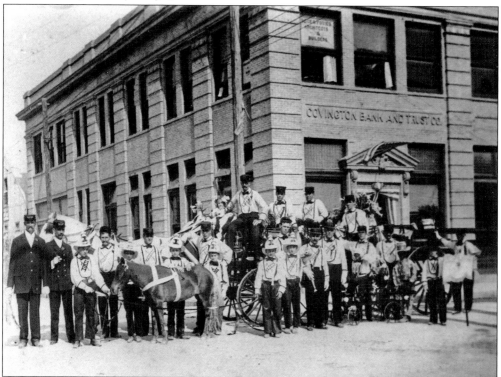

The fire department stands with one of its trucks as it prepares for another parade. (Courtesy of HJS.)

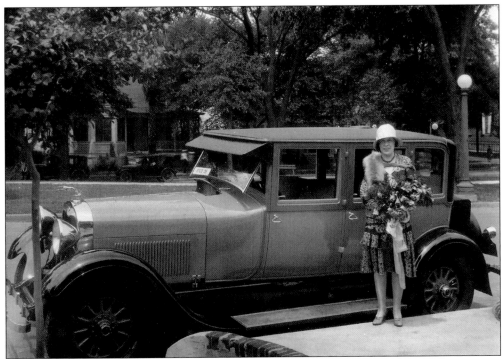

Rose McConnell stands next to a 1924 Lincoln automobile before leaving for the inauguration of her husband, Gov. Huey P. Long. She was just passing through the area, but her sister-in-law, Blanche B. Revere, was born and raised in Covington. She was married to Huey Long's brother, Earl K. Long, who was also elected governor of Louisiana (in 1939, 1948, and 1956). (Courtesy of HJS.)

Meredith "Buster" Lyon (1917–1974) was an educator, the son of educator Elmer Lyon, and an active civic leader in the community. He owned and operated one of the oldest insurance agencies in Covington. A local restaurant on Boston Street bears his name. (Courtesy of Meredith Ramke.)

Three
BUSINESS AND COMMERCE

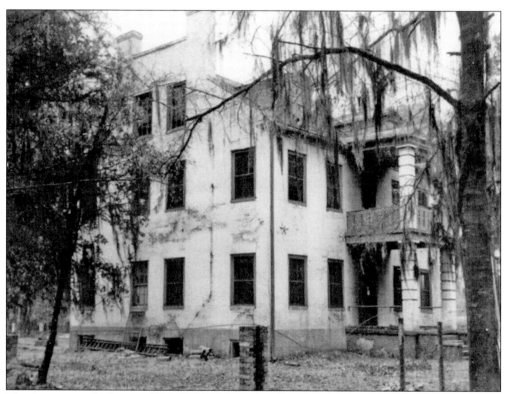

This house was the home of Jesse Ruble Jones, one of the early leaders of Covington. Jones held various public offices in the area and served as a judge for the majority of his life. He was one of the more prosperous citizens of early Covington and helped manage the growth of the city. This house stood on New Hampshire Street close to Bogue Falaya Park. It was torn down in the 1950s. (Courtesy of NC.)

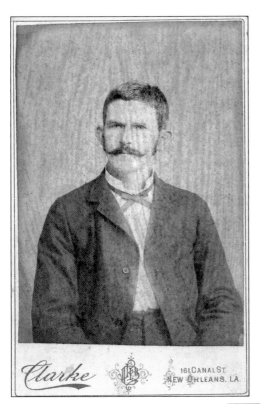

August Benedict Fuhrman was the father of Sidney Fuhrman. He was married to Alice Goodbee, daughter of David Goodbee. August died in 1899, and Alice continued to raise the family in Covington as proprietor of a boardinghouse. (Courtesy of PC.)

Charles Sidney August "Sid" Fuhrman was in the entertainment business both as a performer and promoter. Fuhrman Auditorium was named to honor him and his daughter, Rosemary, who performed on Broadway and had a dance studio in Covington later in her career. (Courtesy of STPL.)

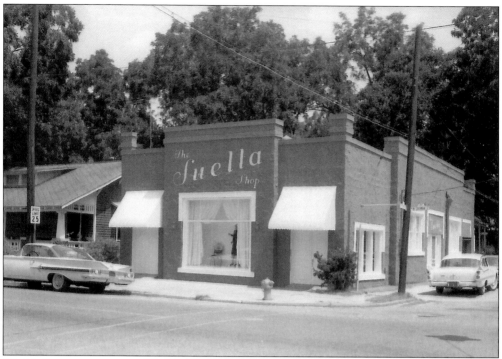

Ella Hadley was proprietor of the Suella Shop on the corner of Gibson and Columbia Streets during the 1960s. It was noted for its distinctive storefront. (Courtesy of Candy Morse Modeen.)

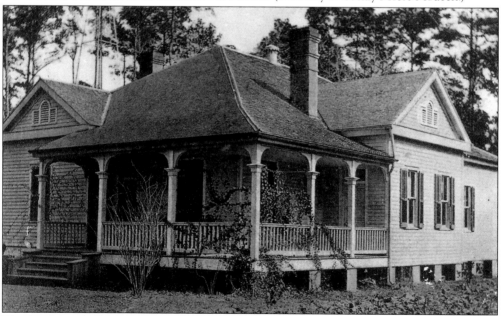

This house was built as a summer home by Jarred Young Sanders, governor of Louisiana from 1908 to 1912. Sanders was part of the political opposition when Huey Long was gaining power. The house passed hands but continued to be used as a summer retreat known as L'Esperance—named for the street on which it is located. *L'Esperance* was also the name of a ship that plied the waters of St. Tammany Parish. (Courtesy of Arnaud Pilie.)

This was the home of Harry A. Mackie, the owner of Mackie's Pine Oil. Born in New Orleans in 1873 and the son of a druggist, he was widowed early but later remarried and lived in this house on New Hampshire and Independence Streets. An interesting note is that Eudora Welty claimed that her writing career began when she won a contest to write a jingle for Mackie's when she was nine years old. (Courtesy of NC.)

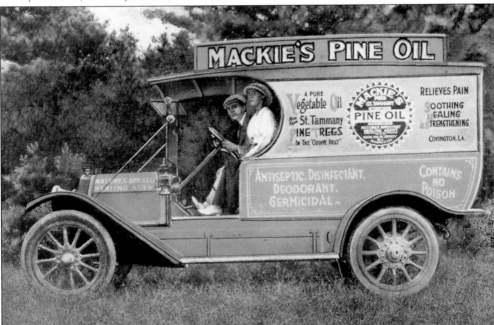

The Mackie's Pine Oil plant was built in 1921 and was situated between Jefferson Avenue and Theard Street near the present-day courthouse. Mackie's products provided much for the economy of Covington throughout its years of existence. The company continued the long tradition of earning a living from the area's pine trees. (Courtesy of RW.)

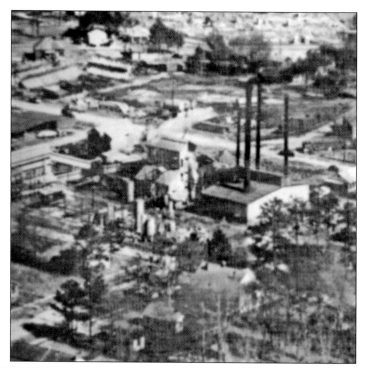

This aerial view shows Delta Pine Products during the 1940s. Delta was on the former site of the Mackie's plant. (Courtesy of RW.)

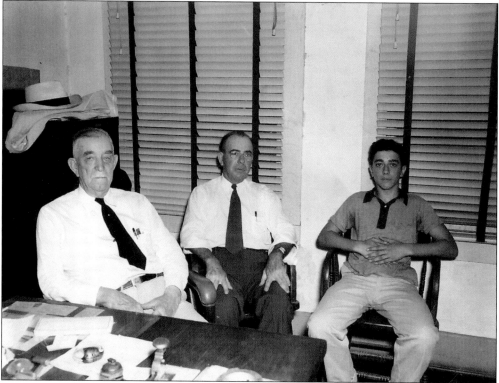

John H. Warner (left) was secretary-treasurer for Mackie's Pine Oil Products and for its successor, Delta Pine Products, a major facility in the downtown area of Covington. (Courtesy of RW.)

This arch was made of pine knots and branches acquired from the Mackie's/Delta operations. It still stands on Twenty-first Avenue on the property once owned by J.H. Warner. It has been duly noted by students on their way to Covington High School for years. (Courtesy of Maria Gibson.)

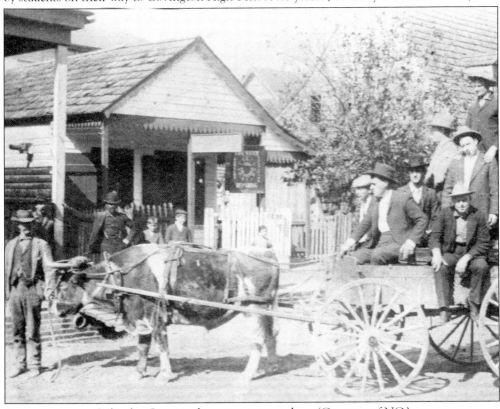

An ox pauses on Columbia Street to have its picture taken. (Courtesy of NC.)

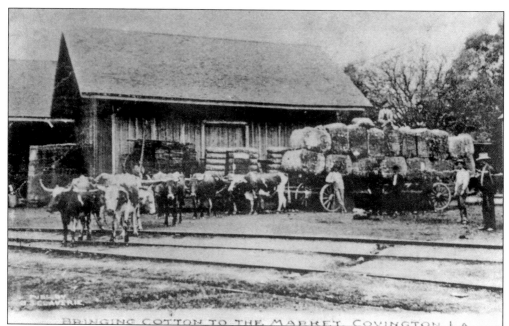

Cotton was shipped through Covington in large quantities in the years leading up to the Civil War. Many of these shipments arrived in town by ox-drawn carts. (Courtesy of STPL.)

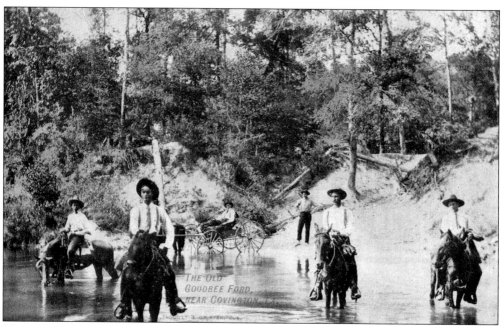

This crossing over the Tchefuncte River was located on the way to Goodbee and was the path for goods to pass to and from Covington, where they could be sold or loaded onto boats or trains for transport beyond St. Tammany Parish. The road continued on to Hammond to the west. Several bridges were built that would eventually wash out during high water until the current was bridge built at Highway 21 and Tyler Street. (Courtesy of STPL.)

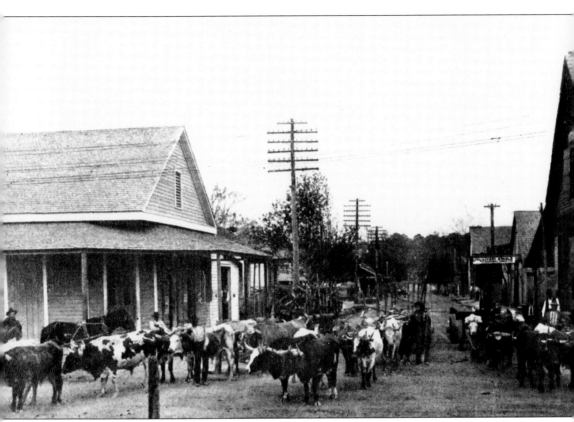
Cattle move through the streets, almost certainly headed for one of the ox lots. (Courtesy of HJS.)

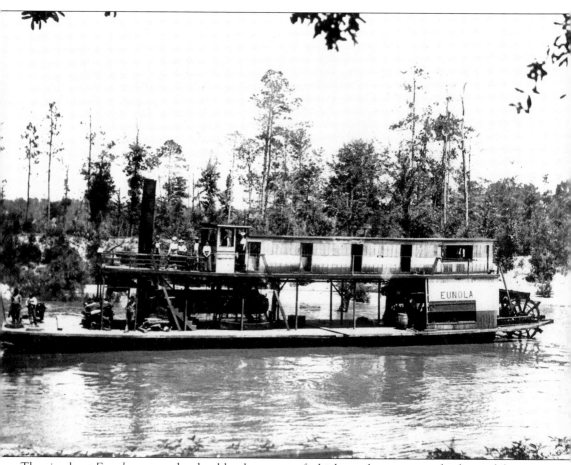

The riverboat *Eunola* was used to haul lumber, some of which can be seen near the front of the boat, seen here around 1908. (Courtesy of GP.)

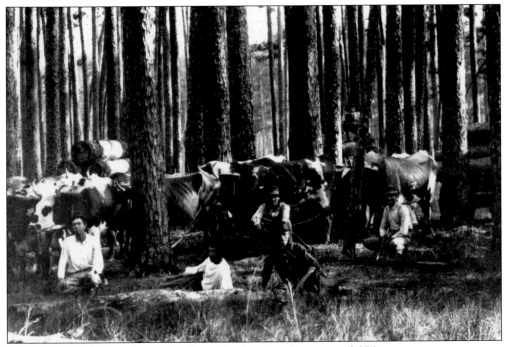
Ox drovers are shown taking a break at a lumber site. (Courtesy of GP.)

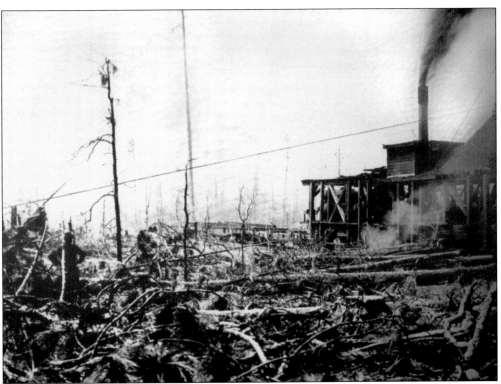
This scene shows one of the Great Southern logging camps around 1920. (Courtesy of GP.)

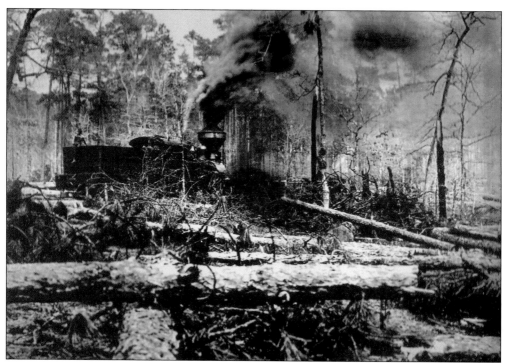

A train pulls into a logging camp in the 1920s. The lumber industry experienced great success when the rail lines were constructed around Covington. (Courtesy of GP.)

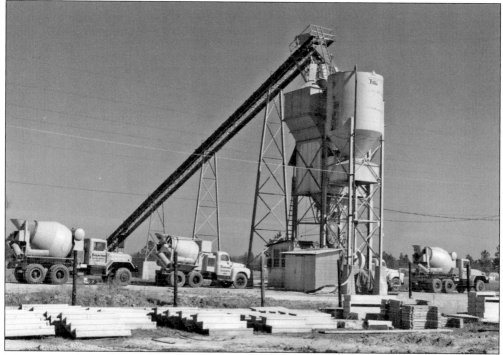

This picture shows the Poole Lumber Company's Redi-mix concrete plant, which was located near the fairgrounds in the 1950s. (Courtesy of GP.)

The Poole Lumber planing mill shown here was located near the St. Tammany Parish fairgrounds. (Courtesy of GP.)

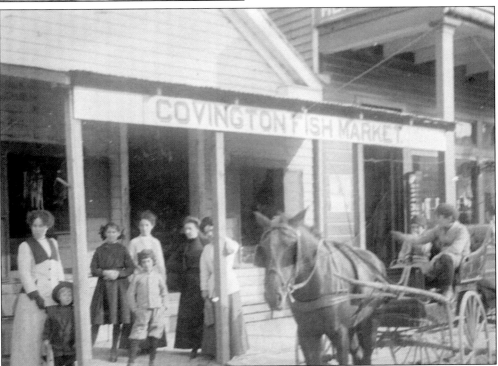

Local residents stand in front of the Covington Fish Market. (Courtesy of NC.)

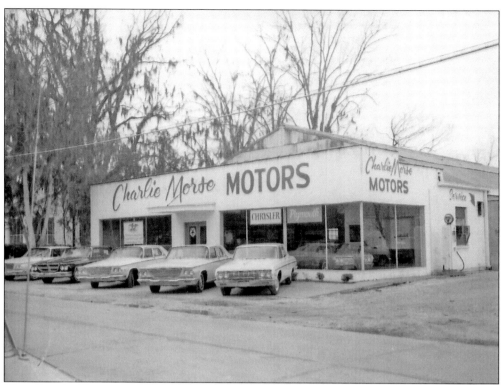

The Chrysler-Plymouth dealership provided transportation for many citizens of Covington. (Courtesy of Candy Morse Modeen.)

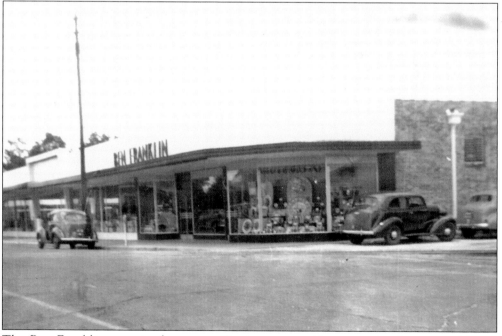

The Ben Franklin store in downtown Covington provides memories for many citizens. (Courtesy of HB.)

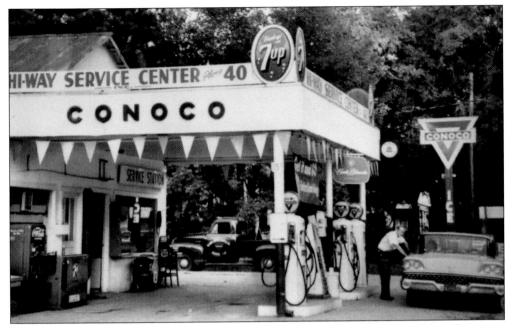

Many in Covington purchased gas at the Hi-Way Service Center, which was located on the corner of Tyler Street and Twenty-first Street. It stood across the street from the Amoco station on one side and from Badeaux restaurant on the other side. The restaurant at this location eventually closed, but one still operates in Madisonville. (Courtesy of GW.)

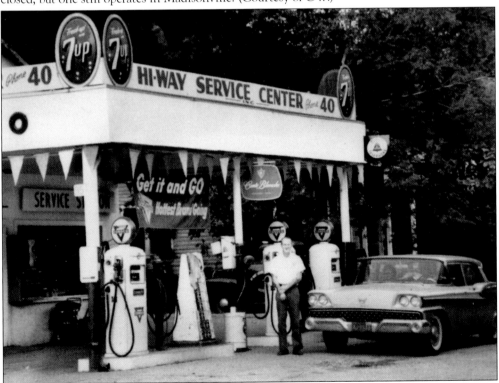

John Schenkler poses in front of the Hi-Way Service Center. (Courtesy of MS.)

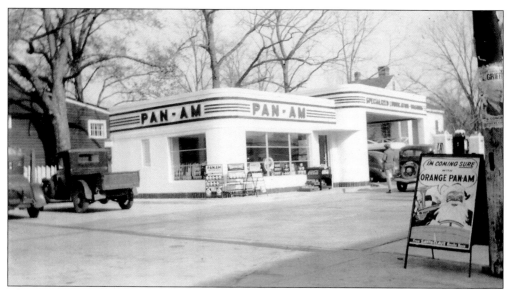

The Pan-Am station had its share of customers working to keep their trucks and cars on the road. (Courtesy of GW.)

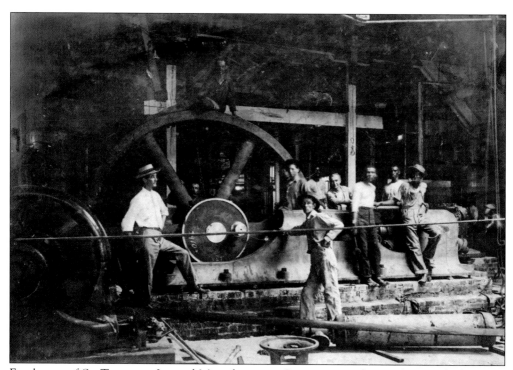

Employees of St. Tammany Ice and Manufacturing Company are shown along with the inner workings of the plant. (Courtesy of NC.)

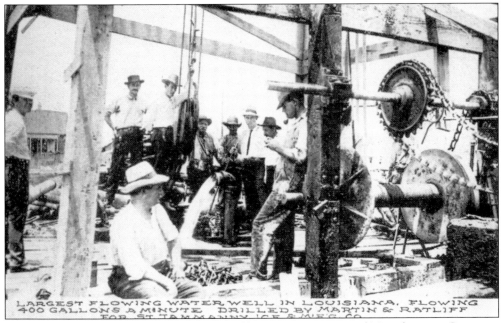
Workers relax with their famous water well, used by St. Tammany Ice and Manufacturing Company. (Courtesy of NC.)

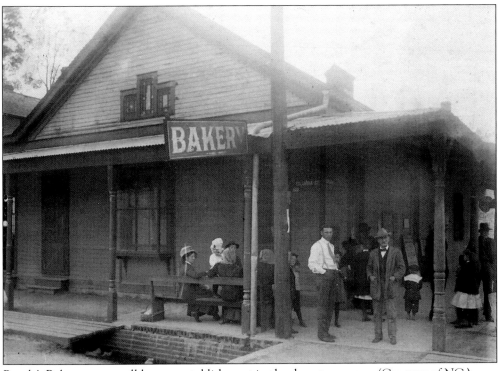
People's Bakery was a well-known establishment in the downtown area. (Courtesy of NC.)

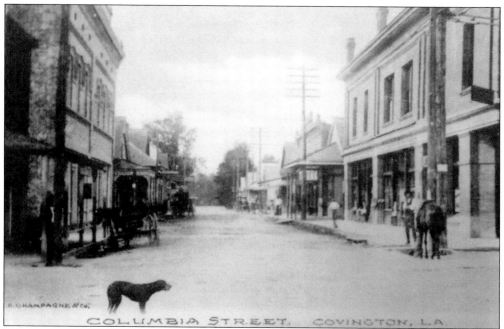
A scene on Columbia Street portrays a tranquil setting among the shops and businesses. (Courtesy of NC.)

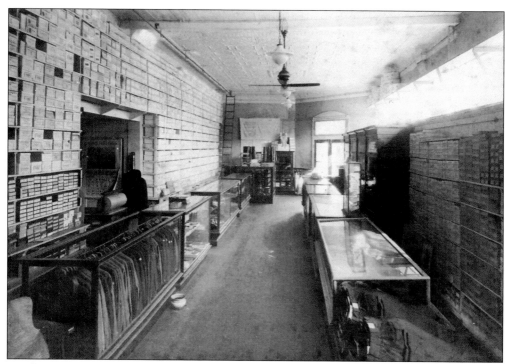
Frank Patacek's store took care of the clothing needs of Covington for many years. (Courtesy of NC.)

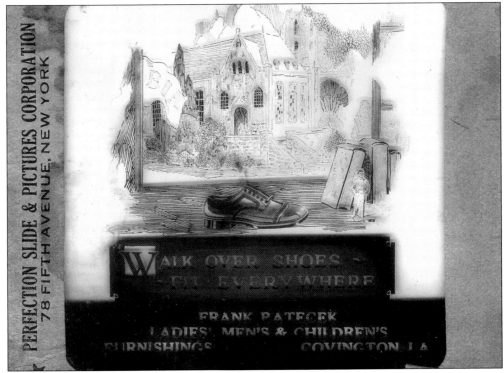

A glass plate for advertisements touts the quality of the shoes sold at Patacek's. (Courtesy of HJS.)

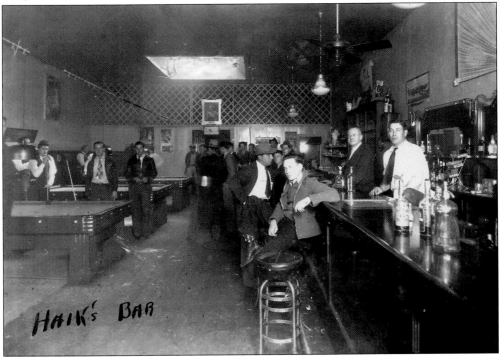

Haik's Bar was one of many watering holes in the downtown area. (Courtesy of NC.)

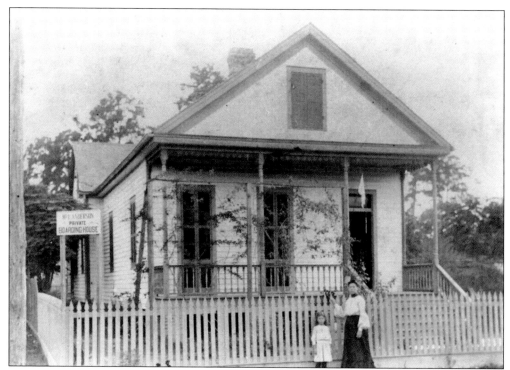

McLanderson's Boarding House demonstrates another area of commerce created as a result of the lure of Covington's peaceful environment. (Courtesy of HJS.)

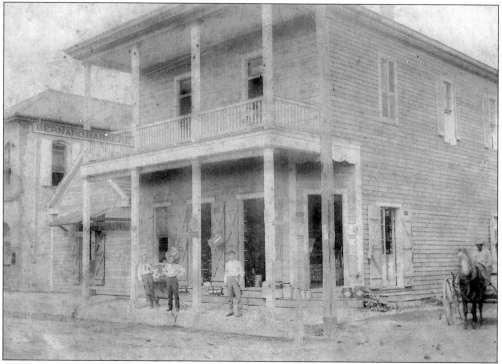

Barrere Mercantile was another business in downtown Covington. (Courtesy of NC.)

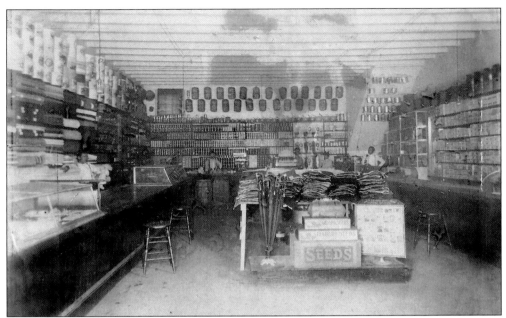
An inside view of the Barrere Mercantile illustrates the variety of goods available for purchase. (Courtesy of NC.)

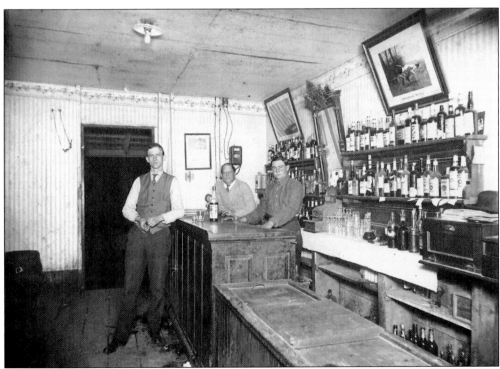
Uly's Bar was another of Covington's saloons, owned by Ulysses Depriest. The reverse side of this 1915 photograph notes the presence of ? Zeuger (left) and Henry Camotte. (Courtesy of NC.)

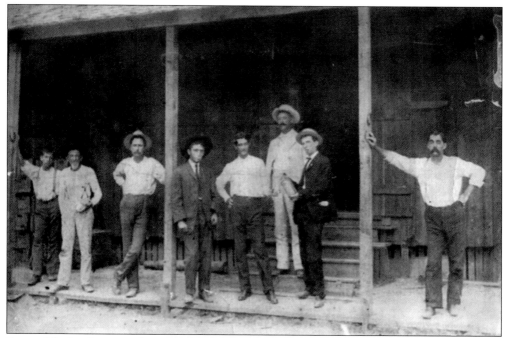

Some of the locals are standing outside Uly's Bar around 1915. It was located on the corner of Theard and Kirkland Streets. From left to right are two unidentified, Charlie Heintz, H.R. "Boy" Warren, Anatole Beaucoudray, Mack Day, ? Menetre, and Emile Beaucoudray. (Courtesy of NC.)

Workers pause for a break on Cooper's Bridge, which spanned the Bogue Falaya River. (Courtesy of NC.)

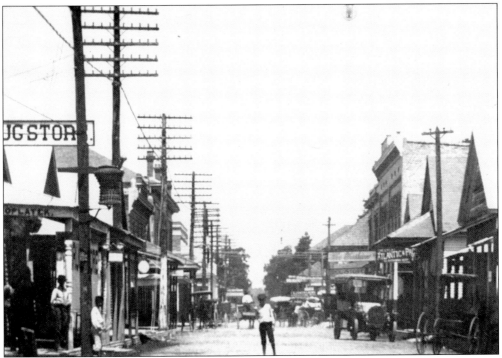

Both sides of Columbia Street show the bustling activity of a growing Covington shortly after the turn of the century. (Courtesy of NC.)

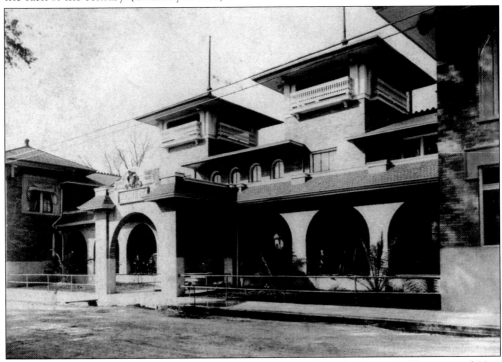

With its distinctive architectural style, the Southern Hotel, on the corner of Boston and New Hampshire Streets, has been a landmark in Covington for decades. (Courtesy of HJS.)

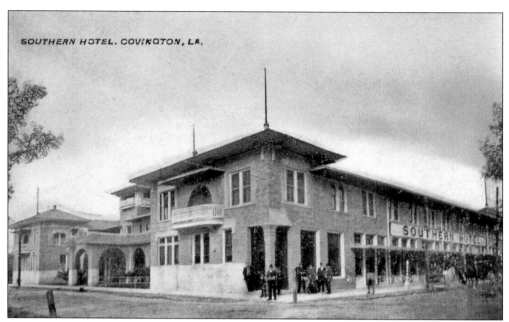

The Southern Hotel had its name emblazoned on the side for pedestrians on New Hampshire Street to view. The hotel was built in 1907. (Courtesy of MB.)

A crowd has gathered around the boiler room of the Southern Hotel, where a fire truck is tending to an alarm. (Courtesy of HJS.)

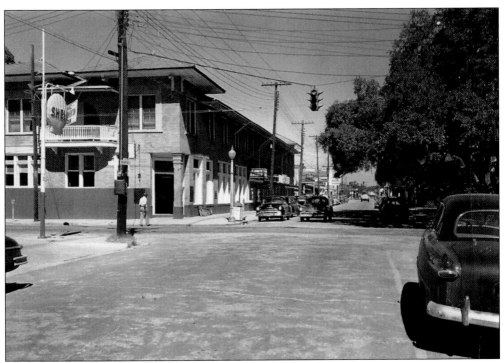

This 1940s view of the Southern Hotel building shows businesses on New Hampshire Street, including Smith Jewelers and Jones Drug Store. (Courtesy of MB.)

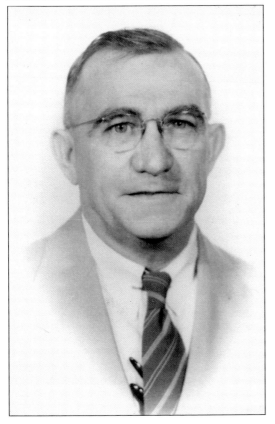

P.E. Smith owned the jewelry store on New Hampshire Street and was another active member of the community. (Courtesy of FM.)

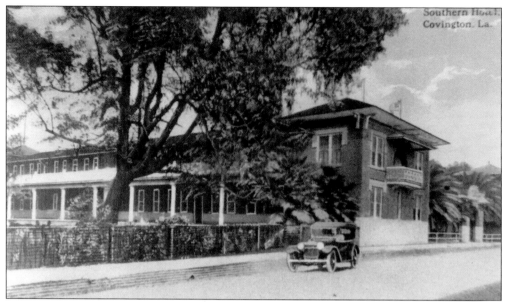

The Southern Hotel shows a bit of elegance in this old postcard. (Courtesy of Bryan Burns.)

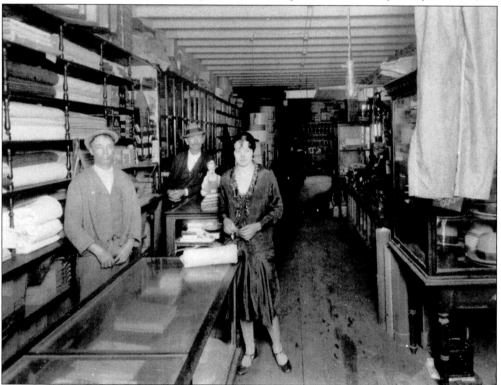

Early Covington citizens stand for a photograph among store merchandise. This is the original building of the H.J. Smith and Sons General Store with a view on the left side looking toward the rear. The current building on Columbia Street is perhaps the single most memorable structure in Covington. Visitors never fail to recall a trip to the old store, which has been converted to a small museum and sits adjacent to the current business. (Courtesy of HJS.)

James Louis "Deed" Smith poses with his wife, Anna Moreel Smith. (Courtesy of HJS.)

Mr. Wright (Sam) was a fixture at Burns Furniture for years. Many appliances and items of furniture passed through his hands. (Courtesy of MS.)

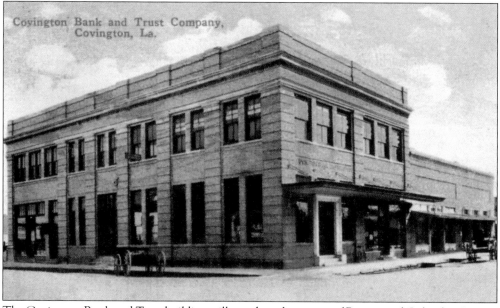
The Covington Bank and Trust building still stands at the corner of Boston and Columbia Streets, where it houses several merchants and businesses. (Courtesy of MB.)

These advertisements from 1908 illustrate some of the businesses operating in Covington near the turn of the century. (Courtesy of SPS.)

Four

TRAINS, BOATS, AND MORE

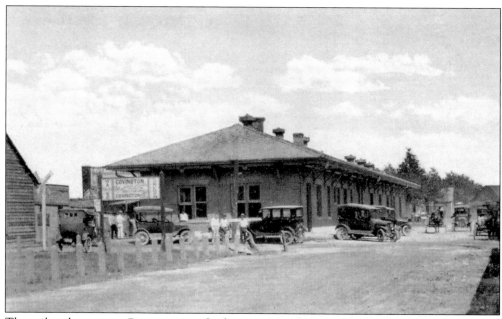

The railroads came to Covington in the late 1800s and sparked a boom in the pine products industry. The depot was situated in the center of town, as it was in most communities. This structure, the original depot, was located on Gibson Street. (Courtesy of NC.)

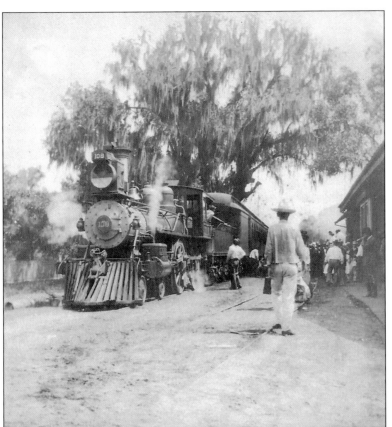

A midday train is shown exchanging passengers at the Covington depot. (Courtesy of NC.)

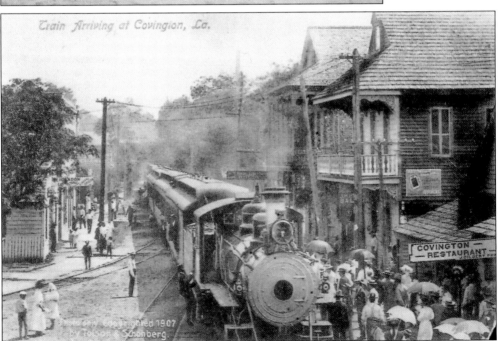

A train from New Orleans arrives at the Gibson Street depot. (Courtesy of MB.)

Railcars cross the Bogue Falaya River on their way to the shore of Lake Ponchartrain, where passengers board ships from and to New Orleans. (Courtesy of MB.)

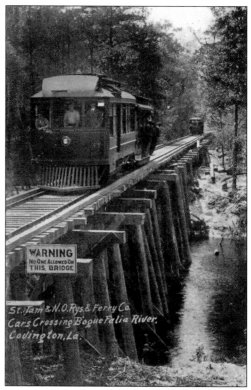

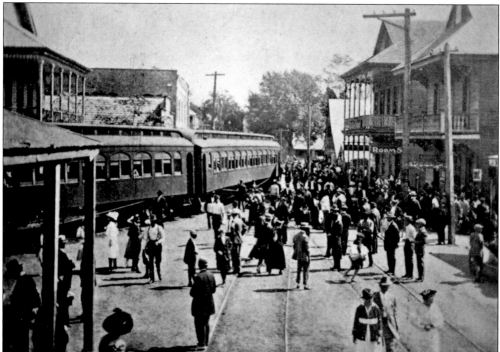

The Gibson Street depot shows a town on the rise around 1915. The street is full of people and activity. (Courtesy of NC.)

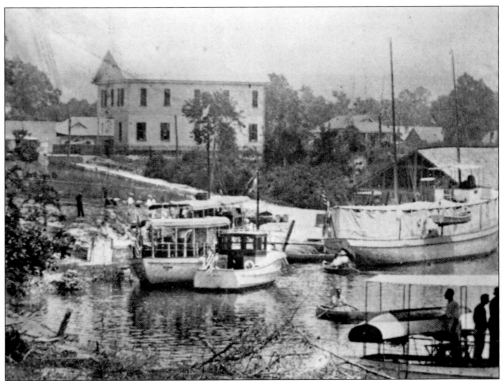

Ships from the Southern Yacht Club are moored at the Columbia Street landing. The building in the background is Masonic Lodge No. 188. A brick meeting hall was constructed by the Masons in 1924 after having seen two previous structures destroyed by fire—once in 1909 and again in 1915. (Courtesy of NC.)

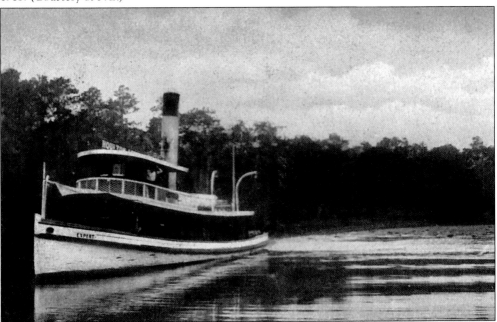

The *Expert* takes a scenic cruise on the Bogue Falaya River. (Courtesy of NC.)

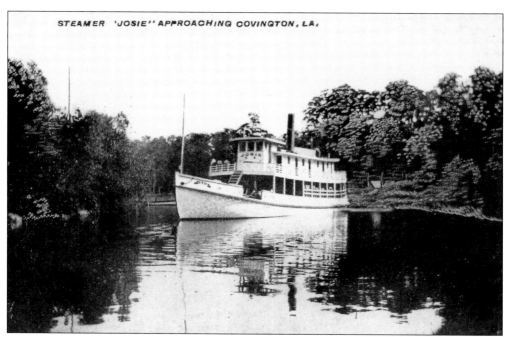

The *Josie* waits in the Bogue Falaya River before docking at the landing at the end of Columbia Street. (Courtesy of NC.)

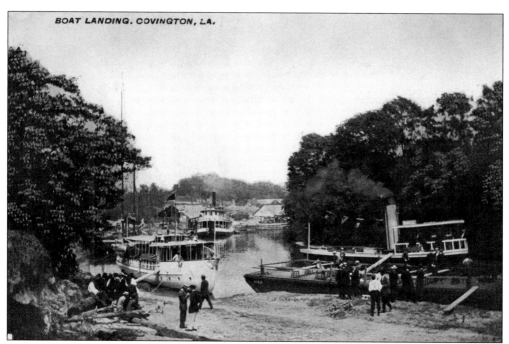

This postcard shows some of the larger boats that docked at the landing in Covington. (Courtesy of CG.)

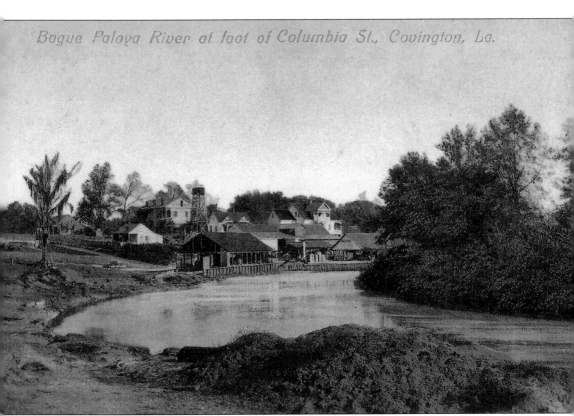

A view of the landing at the foot of Columbia Street shows the bend in the Bogue Falaya River as well as some of the homes built near the water. (Courtesy of MB.)

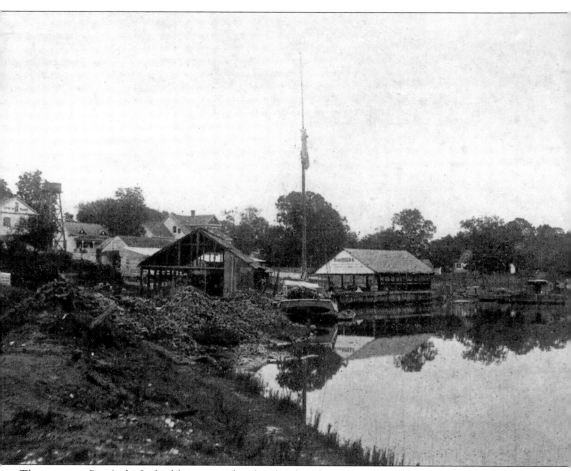

The steamer *Rosa*'s dock shed became a familiar landmark at the landing on the Bogue Falaya River. Today, the landing no longer has this open look; it is surrounded by buildings and trees. (Courtesy of NC.)

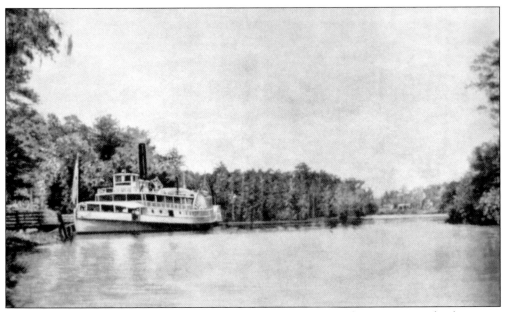

The *New Camelia* is securely docked and is most likely waiting to pick up passengers for the return trip to New Orleans. (Courtesy of NC.)

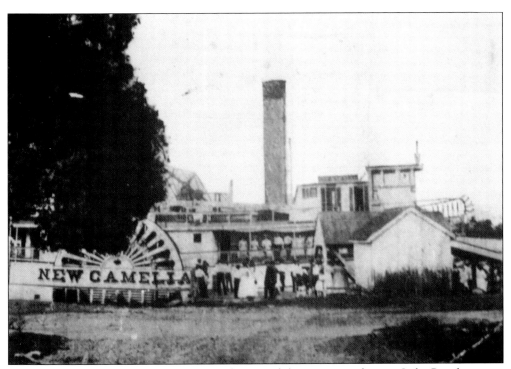

The *New Camelia* was arguably the most famous of the transport ships in Lake Ponchartrain. She regularly made trips from Milneburg in New Orleans to the Tchefuncte and Bogue Falaya Rivers. (Courtesy of NC.)

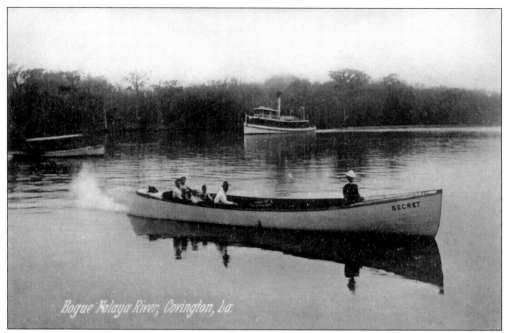

The Bogue Falaya River saw heavy boat traffic both for industry and for excursions to bring vacationers on holiday. (Courtesy of NC.)

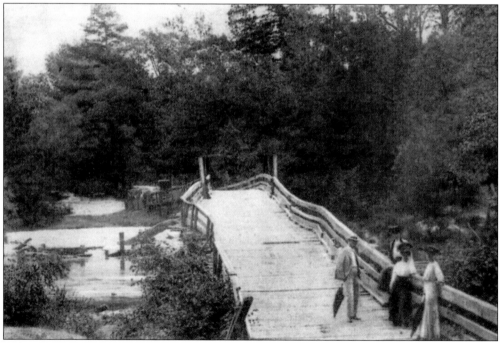

A few of the locals pause on the Bogue Falaya bridge. The bridge has a "kink" in it where it was struck by debris during high water. (Courtesy of MB.)

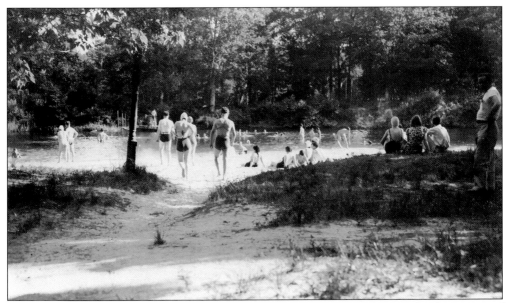

Charropin Park was located on the Bogue Falaya River and was a popular spot for the citizens of Covington to spend leisure time. People would spend hours relaxing on the beach, swimming in the water, or boating up and down the river. This photograph shows the popularity of the park with a view from the path leading to the beach. (Courtesy of Norcom Jackson.)

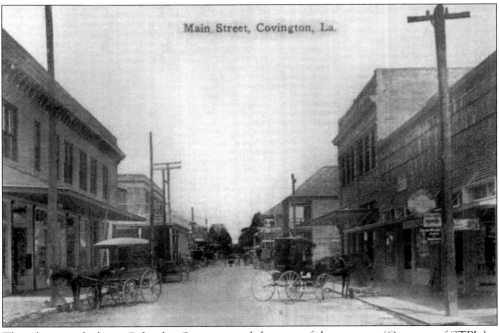

This photograph shows Columbia Street around the turn of the century. (Courtesy of STPL.)

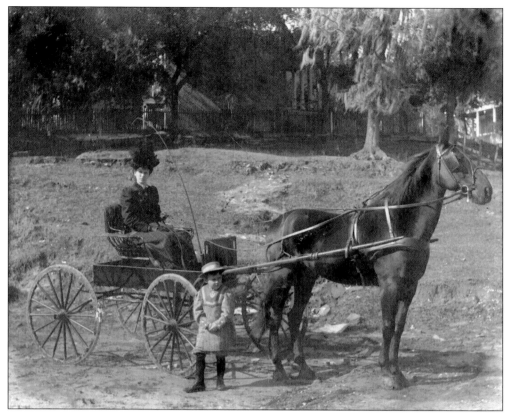

Minnie Depriest Coltora and her son, Frank, are out for a Sunday drive near the Columbia Street landing. (Courtesy of NC.)

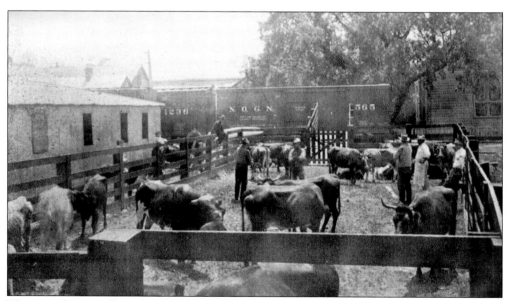

These cattle are milling around in a pen, waiting to be shipped out on the train. In the dusty background appears to be a side view of the Methodist church. (Courtesy of NC.)

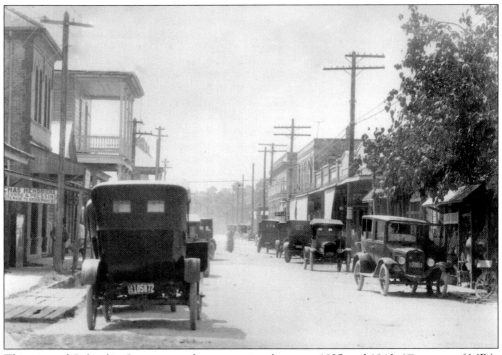
This view of Columbia Street was taken some time between 1925 and 1940. (Courtesy of MB.)

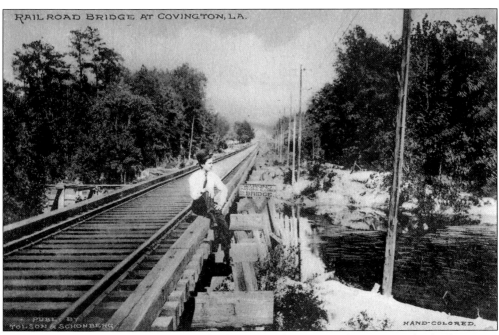
An unknown man relaxes on the train bridge across the Bogue Falaya River. This bridge was at the end of Boston Street and crossed over to the Claiborne Hill area. The sign reads "NO ONE ALLOWED ON BRIDGE." (Courtesy of MB.)

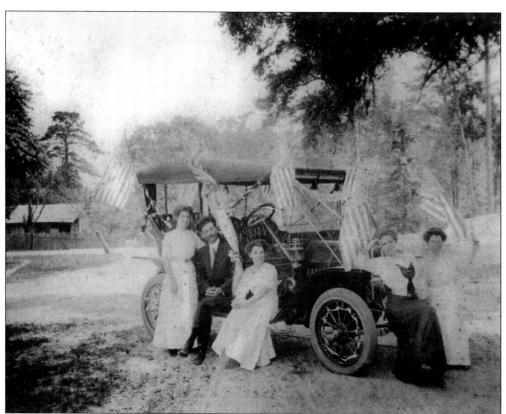

Deed Smith poses with one of the first cars to ride the streets of Covington. Annie C. Smith is on the far right, but the other women are unidentified. (Courtesy of HJS.)

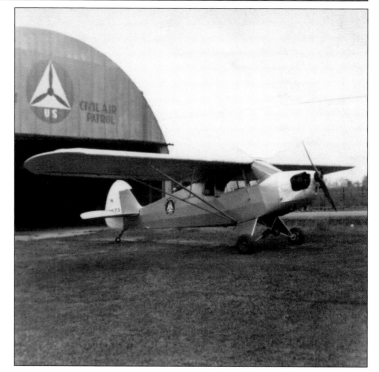

A 1940 Piper J5A plane sits in front of the Civil Air Patrol (CAP) hangar previously located in north Covington at Keen-Privette Field. Local volunteer pilots formed a flight club that constituted the Covington CAP. (Courtesy of RW.)

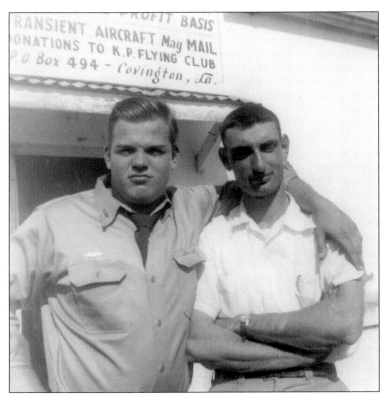

Cy Plummer (left) and Godfrey Roach stand together in front of a sign explaining terms of the Keen-Privette flying club. The airstrip was located near the intersection of Highway 190 and Highway 25. One of the access roads was, naturally, Airport Road. (Courtesy of RW.)

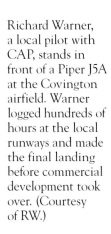

Richard Warner, a local pilot with CAP, stands in front of a Piper J5A at the Covington airfield. Warner logged hundreds of hours at the local runways and made the final landing before commercial development took over. (Courtesy of RW.)

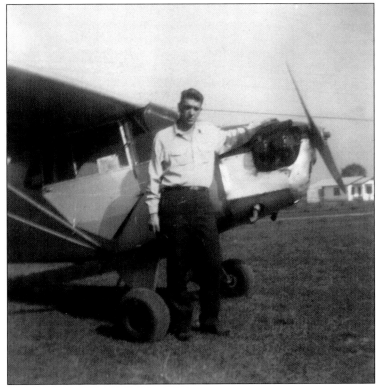

Five
Rest, Relaxation, and Fun!

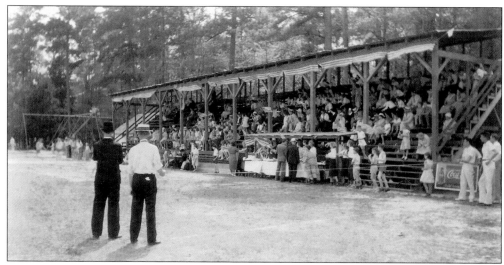

Townspeople eagerly await the completion of a footrace at a field day held at St. Paul's College. For most of Covington's existence, it has served as a vacation spot for visitors from New Orleans and other areas. Many came for the peaceful surroundings and clean country air, but others expected entertainment and other diversions. Covington was able to provide all of these. (Courtesy of SPS.)

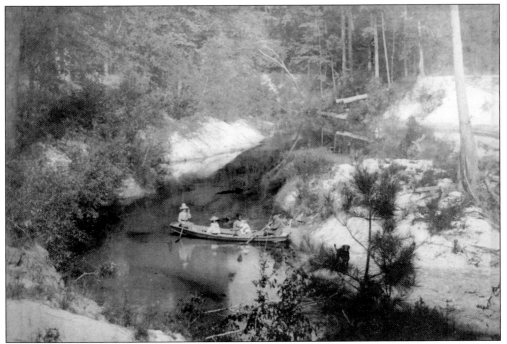

Some of Covington's citizens are shown boating on the Bogue Falaya River. Sand levels and debris indicate the high-water mark in the spring. Note the dog that appears to be standing in a pine tree due to the perspective. (Courtesy of GP.)

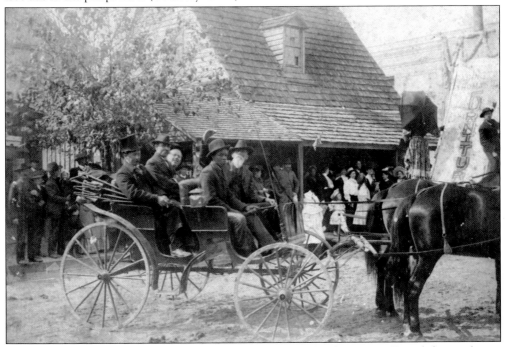

This c. 1905 image captures Covington Mardi Gras on Columbia Street. From left to right are (front seat) Frank Elliot and William Depriest; (back seat) Warren Badon, E.J. Frederick, and Mack Day. (Courtesy of NC.)

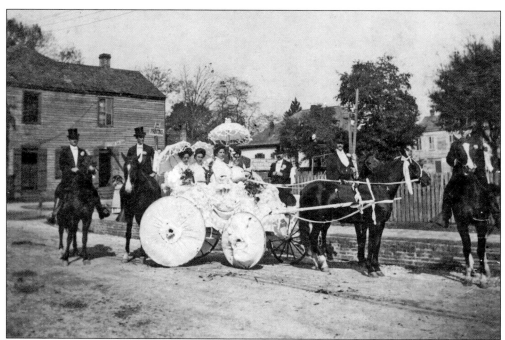
Another Mardi Gras carriage holds ladies in their finery with their escorts on horseback. (Courtesy of NC.)

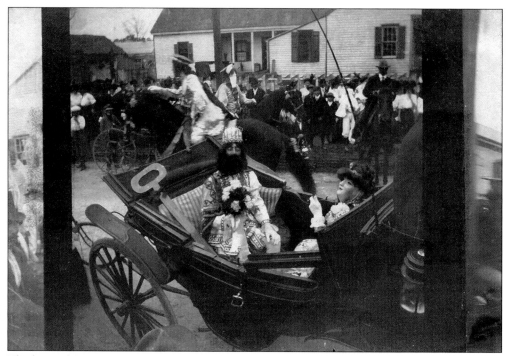
The king of Covington Mardi Gras sits in a carriage with his escort. (Courtesy of NC.)

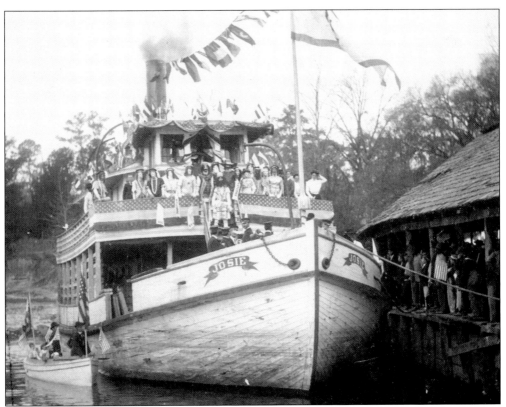

The king continues his revelry along the Bogue Falaya River aboard the *Josie*. (Courtesy of NC.)

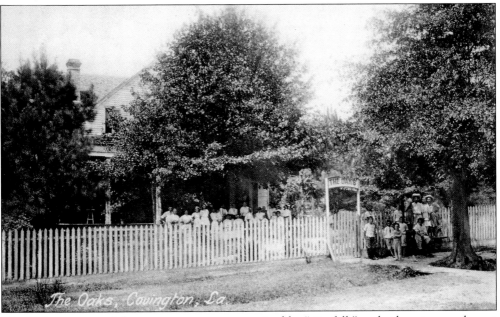

The Oaks was one of the many summer retreats used by "city folk" and others to spend some relaxing time around Covington. (Courtesy of MB.)

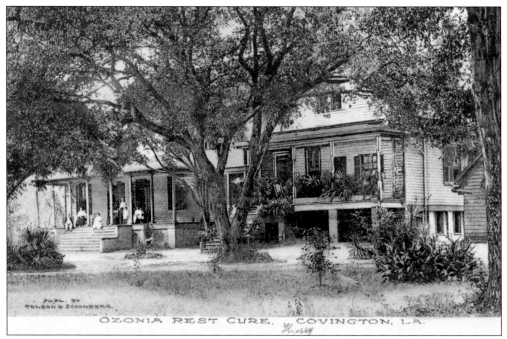
The Ozonia Rest Cure also provided a spot for a quiet stay. (Courtesy of MB.)

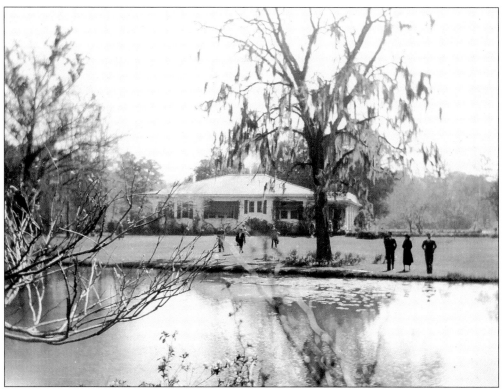
The McGinnis home on Lee Road provides justification for Covington's inclusion in the "Ozone Belt," thanks to the pastoral setting of lake, trees, Spanish moss, and clean air. (Courtesy of HB.)

The Fallon house is reported to be the oldest house in Covington. (Courtesy of NC.)

The Bascle home is situated on the old Hammond Highway. (Courtesy of NC.)

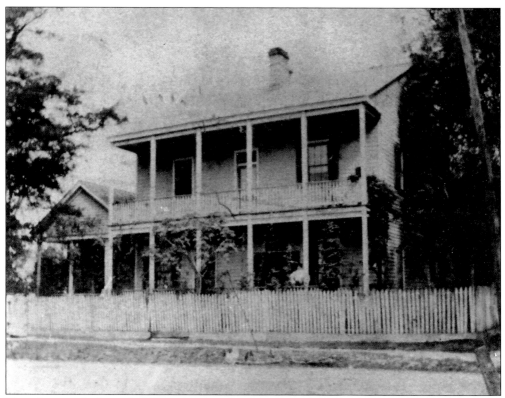
This photograph shows the Martindale home in 1920 at the corner of Rutland and New Hampshire Streets. Taylor's Barber Shop and Clanton's Cigar shop are on that site today. (Courtesy of PC.)

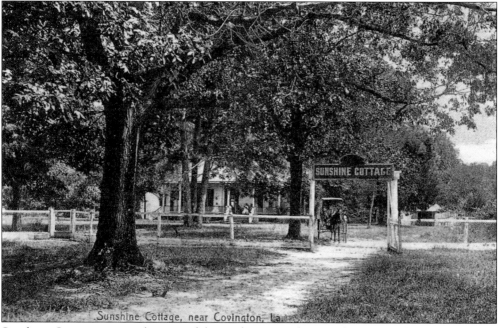
Sunshine Cottage was another one of the spa houses in the area. (Courtesy of MB.)

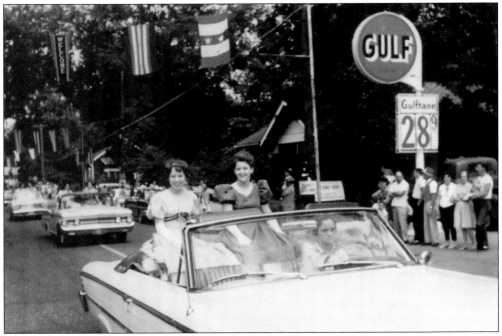

Covington celebrates with a downtown parade around 1960. (Courtesy of MB.)

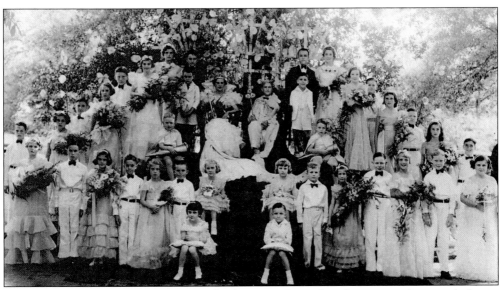

Students of the Covington Grammar School arrange themselves for a group photograph during their school's May festival in 1935. May festivals were very popular events during the 1930s and 1940s. (Courtesy of PC.)

Muggins Burns poses as the Queen of May for a festival in 1935. (Courtesy of HB.)

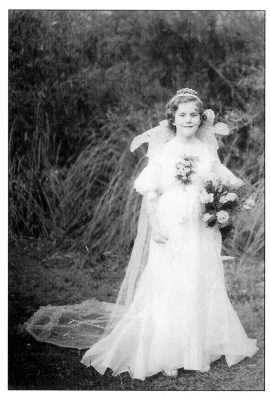

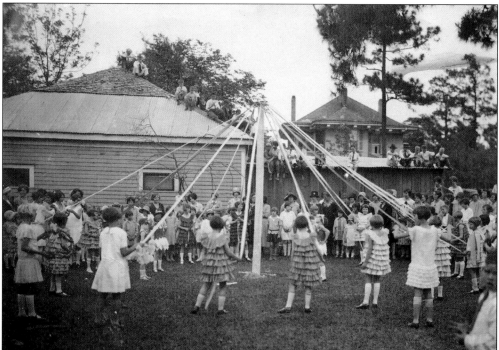

The Presbyterian church had a May festival that brought children out of the woodwork . . . and onto the rooftops! (Courtesy of NC.)

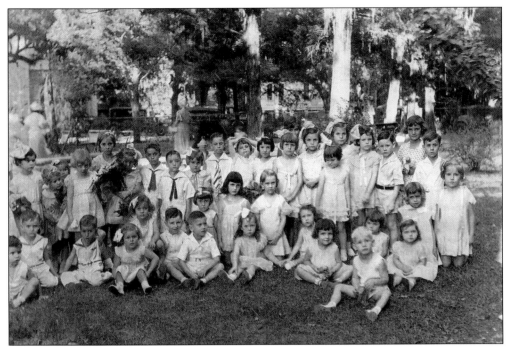

Another happy group of students poses for a picture during the St. Scholastica Academy May Festival. (Courtesy of PC.)

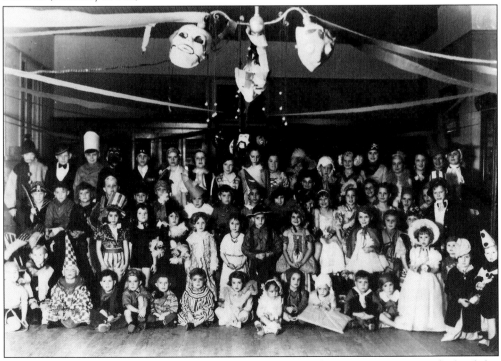

Many of the town's children are shown gathered for a Mardi Gras party as part of a birthday celebration for Jimmy and Patricia Burns. This picture was taken around 1935 in the old library, which later became part of Christ Episcopal Church. (Courtesy of PC.)

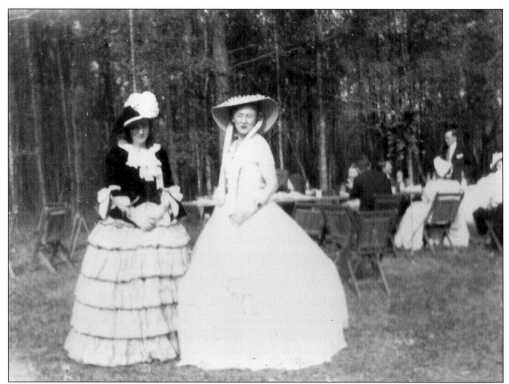

Villa de la Vern was one of the retreats used for relaxing days in Covington. Here are two women in period dress some time during the late 1930s or early 1940s. (Courtesy of HB.)

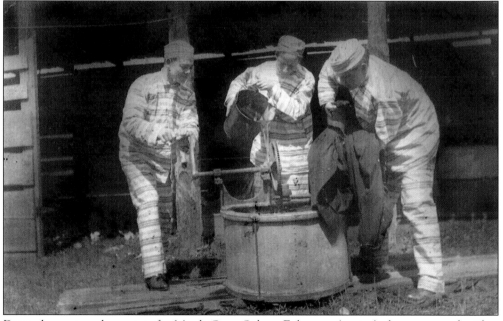

Dressed as escaped convicts for Mardi Gras, Sidney Fuhrman (center) clowns around with a couple of friends. (Courtesy of PC.)

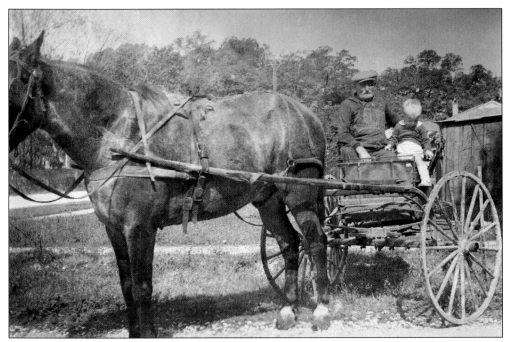

This picture shows Boss Frederick in the horse and carriage that became his trademark during his later years. His grandson Freeman McGlothlin sits by his side with Attaboy hitched and ready to go. (Courtesy of PC.)

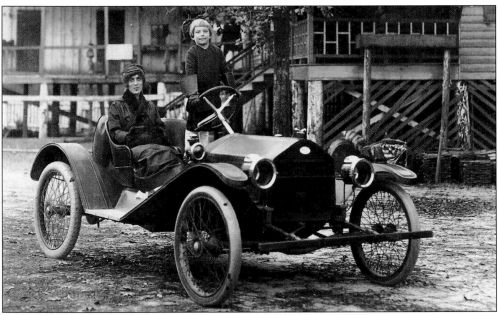

The 1920s Metz car was shipped in kits for the owner to assemble, one step at a time. This particular car belonged to the Warner family and sat in the backyard for years. It was donated to the war effort in the 1940s for scrap metal. (Courtesy of RW.)

Lillie Walker of Lee Lane seems to indicate that parenting could sometimes be a headache in the old days, too. (Courtesy of the Walker House.)

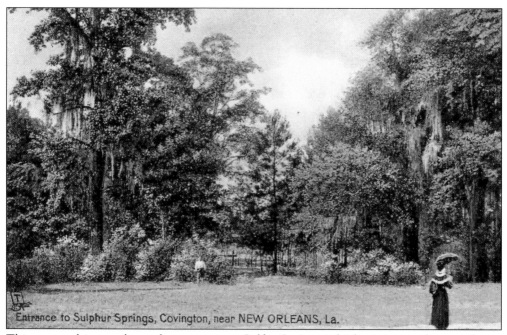

This postcard image shows the entrance to Sulfur Springs, which was a popular area for an enjoyable walk or a swim in the cool water. (Courtesy of MB.)

A motorist stops in front of Daull's Flower Shop on New Hampshire Street in the late 1930s. (Courtesy of HB.)

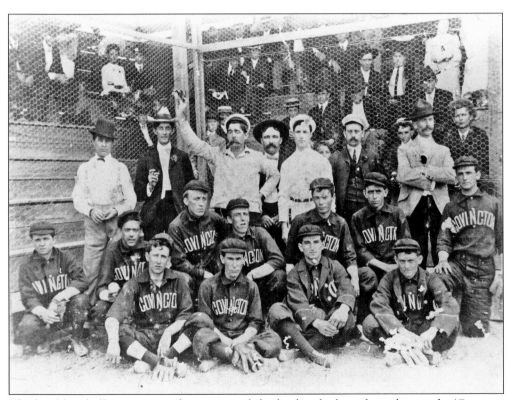
The local baseball team poses after a game while the fans look on from the stands. (Courtesy of HJS.)

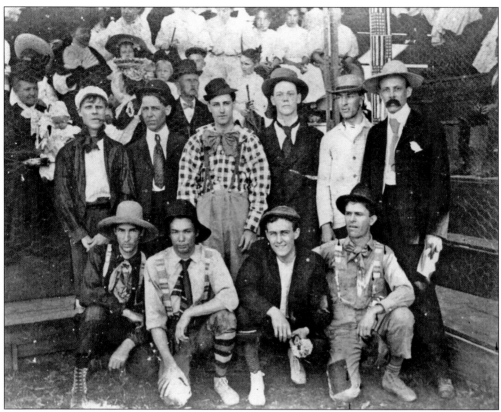

This photograph was taken on what seems to have been a costume day at the ballpark, although most of the players seem none too thrilled about the arrangement. Perhaps it was during the Mardi Gras season. (Courtesy of HJS.)

Here is another photograph of a Covington baseball team. (Courtesy of HJS.)

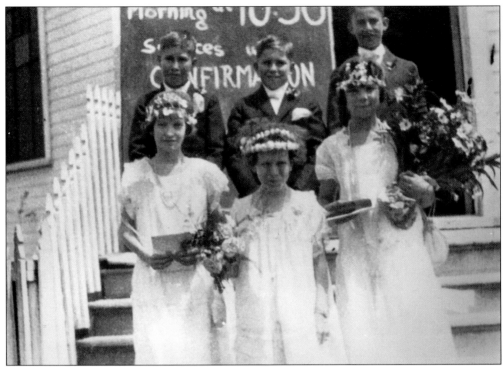

Children of Covington pose on the day of their confirmation in 1925. From left to right are (first row) Ruth Burnett, unidentified, and Agnes Otto; (second row) Norman Marsolan, Stanton ?, and Vallery LaMar. (Courtesy of MB.)

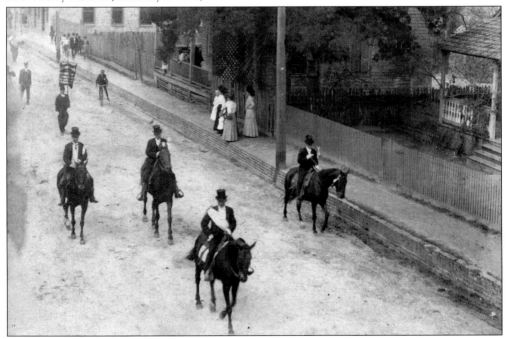

The Covington Volunteer Fire Department parades through downtown on Columbia Street between Gibson Street and Lockwood Street. (Courtesy of NC.)

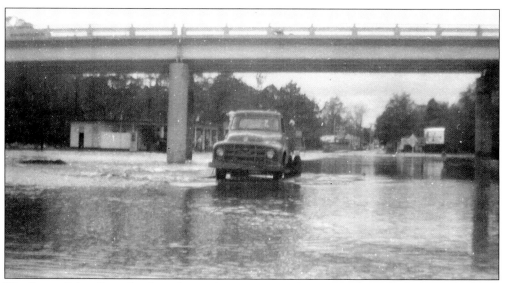

The Bogue Falaya River has brought much commerce to Covington through the years, but it can also be a force to reckon with—as it was during the flood of 1961. These photographs show how the water reached the streets of the city. (Courtesy of GW.)

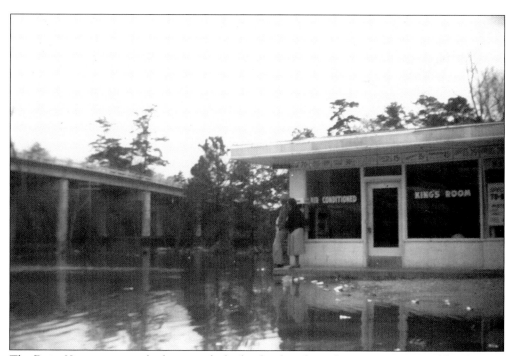

The Dairy King was a popular hangout for high school students. It too was a victim of floodwaters. (Courtesy of GW.)

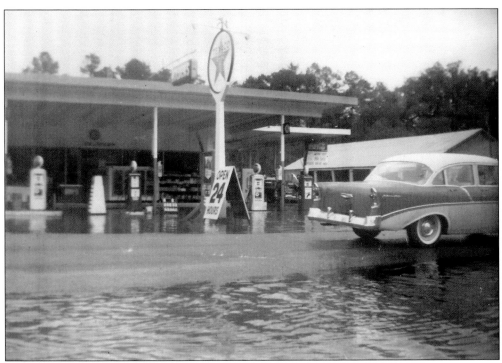
The Texaco station barely escaped being flooded. (Courtesy of GW.)

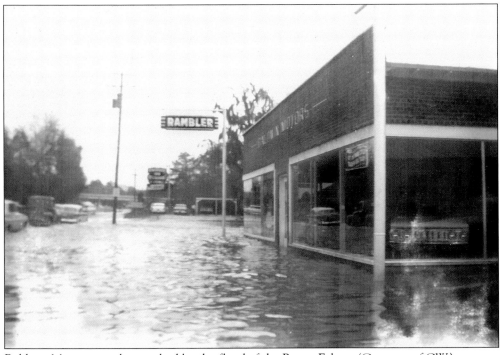
Baldwin Motors was also touched by the flood of the Bogue Falaya. (Courtesy of GW.)

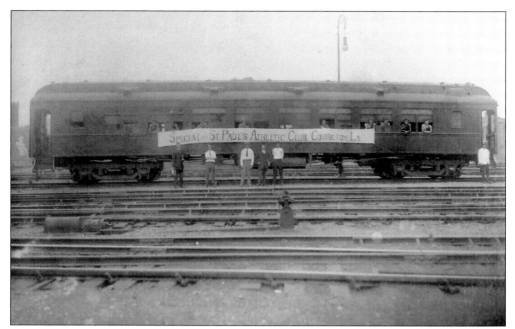

Sometimes, the trains passing through Covington would take the locals to points beyond. Here a St. Paul's athletic team departs for an out-of-town game. (Courtesy of SPS.)

From left to right, Eulalie Wagner, her son Louis, and her sister Cecile Pinter enjoy a pleasant afternoon in the 1920s. Louis Wagner would grow up to become principal at Covington High School. He was also a local historian; his efforts helped to preserve many of the records of Covington's past. (Courtesy of GW.)

Seen here is the Schultz house in 1908, located on Kemper Street (now Lee Lane). Christiana Schultz poses with her son, Hermann, and her daughter, Annie. (Courtesy of NC.)

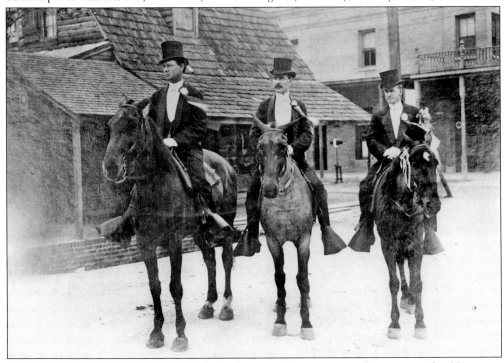

Three of Covington's notables are decked out as they wait to ride in a parade. (Courtesy of NC.)

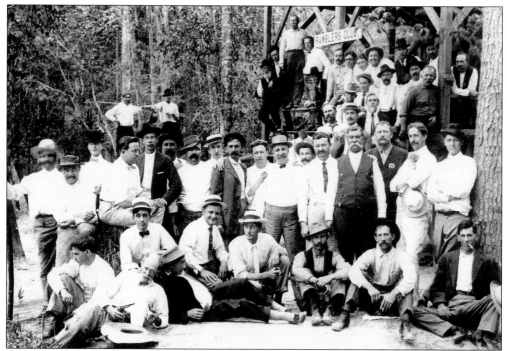

Ramblers Clubs were originally created as walking clubs, many of which evolved into hunting or nature clubs. Seen here from left to right are (first row) are George Heintz, ? Austin, ? Badon, ? Del Coral, Anatole Beaucoudray, J. Louis "Deed" Smith, Tom Hebert, and unidentified; (second row) ? Galouye, Marcus ?, ? Boles, unidentified, Paul Lacroix, E.V. Richard, Julius Heintz, ? Lafayette, ? Badot, Nick Seiler, Frank Davidson, Amedee Guyol, Albert Perbos, Caz Segond, E.J. Frederick, Frank Patecek, Dr. Marrero, Bill Fussell, Max Loyd, and Jim Mullaly; (third row) Sidney Frederick, ? Peters, Louis Hebert, Emile Frederick, ? Zinzer, Leon Hebert, Wallace Poole, Ed Evans, Boy Warren, ? Claverie, Bob Badon, Willie Kennedy, Fen Martindale, Vic Frederick, ? Galouye, Al Blattner, H.J. Smith, Guy Zorn, and Fred Lacroix. (Courtesy of HJS.)

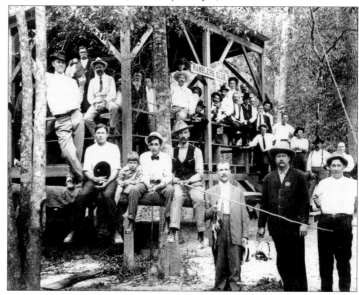

The members of the Covington Ramblers Club appear to be outdoorsmen. A close inspection shows certain members holding guns or fishing rods. (Courtesy of HJS.)

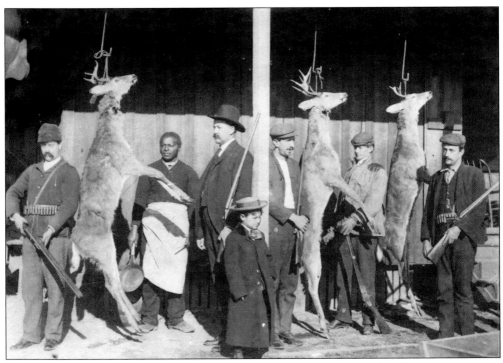

Some of the hunters seen above were surely members of the Ramblers Club. The back of the photograph indicates that the hunt took place at the Morris retreat around 1915. (Courtesy of NC.)

Alice Galmiche Poole was born in 1881 to French parents. Wallace Maurice Poole was born in 1883. The couple married about 1908, and they began a life in Covington as farmers. (Courtesy of GP.)

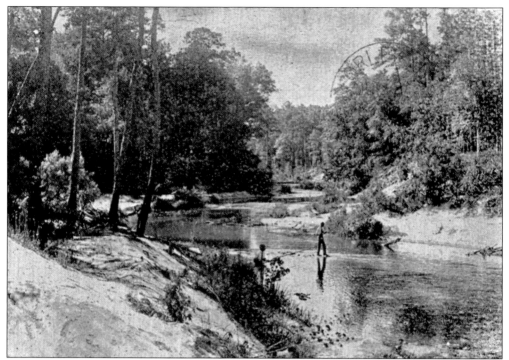
Fishermen try their luck at a calm bend in the Bogue Falaya River. (Courtesy of STPL.)

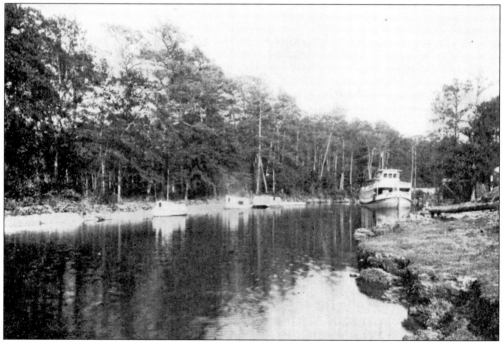
An unidentified ship plies the waters of the Bogue Falaya River. When one considers the history of Covington, the one constant is always the river. (Courtesy of SPS.)

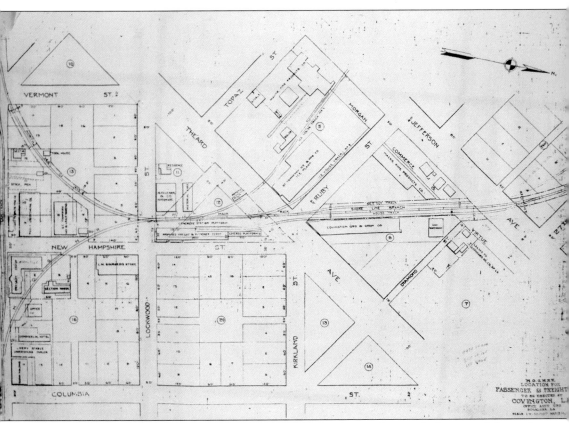

This 1918 map shows the location of the original train depot, along with the second depot that was in the planning stages when this drawing was created. The first depot is the L-shaped building at the corner of New Hampshire and Gibson Streets. The second depot structure still stands and houses a restaurant on New Hampshire Street between Lockwood and Theard Streets. The St. Tammany Ice and Manufacturing plant is situated at the corner of Theard and Ruby Streets, now Twenty-Sixth Avenue. The ox lots can also be seen in the center of the original blocks. (Courtesy of MB.)

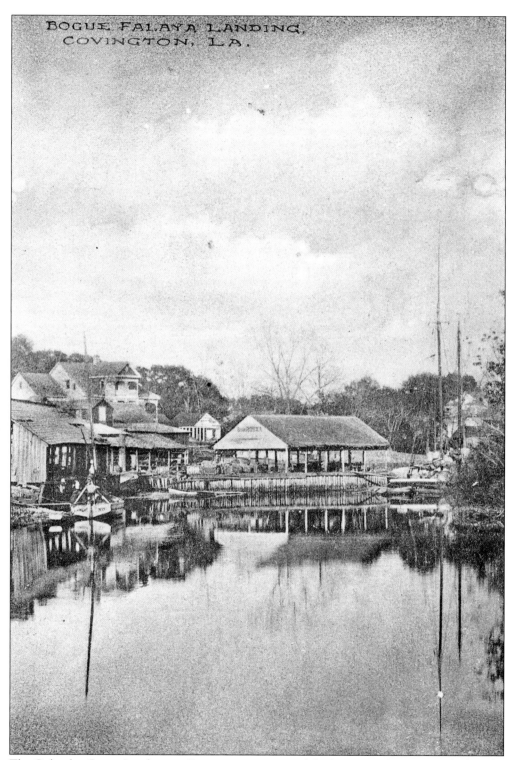

The Columbia Street Landing in Covington saw most of the business of Covington before the railroads were built in the area. (Courtesy of CG.)

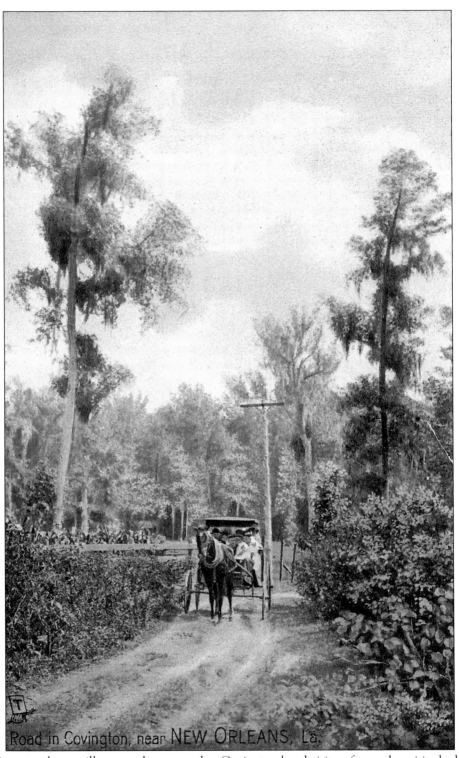

This pastoral scene illustrates the reason that Covington lured visitors from other cities looking for a peaceful spot for a holiday. (Courtesy of MB.)

BIBLIOGRAPHY

Ellis, Frederick S. *L'Autre Cote' du Lac*. Gretna, LA: Pelican Publishing, 1981.
Holden, Doris. *On through the Years with Abner Jenkins*. Covington, LA: 1997.
Jahncke, Carol Saunders. *Covington Revisited*. Covington, LA: Covington Press, 1985.
———. *Mr. Kentzel's Covington*. Baton Rouge, LA: Legacy Publishing, 1979.
Kemp, John R. and S. Harvey Colvin Jr. *St. Tammany, 1885–1945, a Photographic Essay*. Covington, LA: St. Tammany Historical Society, 1981.
St. Tammany Historical Society. *Home Cooking: Recipes, Homes, and Legends of St. Tammany Parish, LA*. Covington, LA: St. Tammany Historical Society, Inc.
St. Tammany West Chamber of Commerce. *Legends of Covington Cemetery No. 1*. Covington, LA: W.T. Kentzel, Inc., 1988.

Discover Thousands of Local History Books Featuring Millions of Vintage Images

Arcadia Publishing, the leading local history publisher in the United States, is committed to making history accessible and meaningful through publishing books that celebrate and preserve the heritage of America's people and places.

Find more books like this at
www.arcadiapublishing.com

Search for your hometown history, your old stomping grounds, and even your favorite sports team.

Consistent with our mission to preserve history on a local level, this book was printed in South Carolina on American-made paper and manufactured entirely in the United States. Products carrying the accredited Forest Stewardship Council (FSC) label are printed on 100 percent FSC-certified paper.

MADE IN THE USA